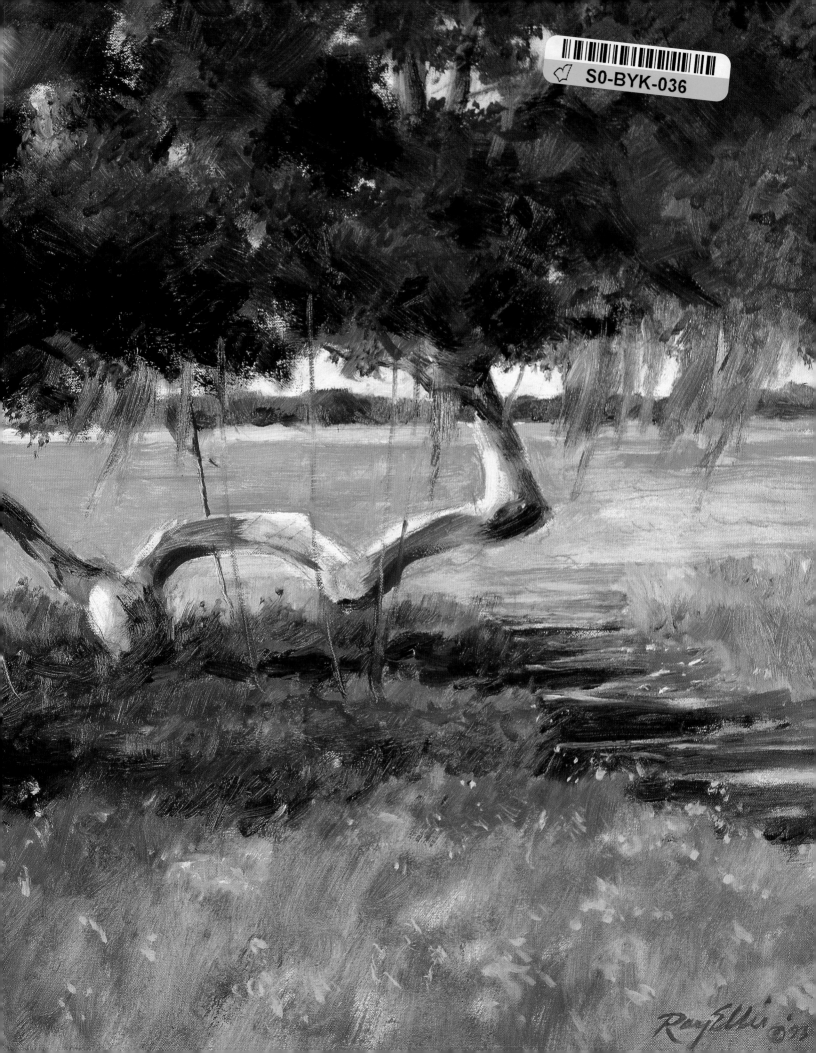
S0-BYK-036

# Savannah
## AND THE
## Lowcountry

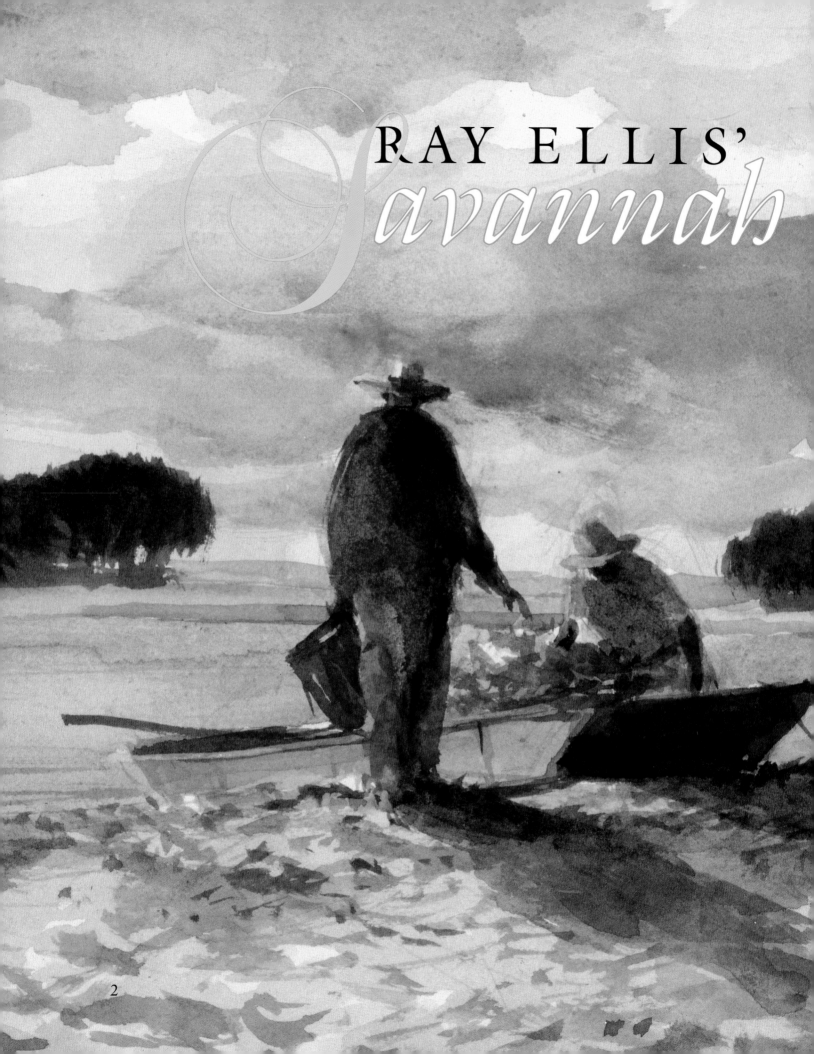

# RAY ELLIS' *Savannah*

# &the Lowcountry

Introduction by Arthur Gordon

COMPASS PUBLISHING • SAVANNAH

© 1994 Compass Publishing, 205 West Congress Street, Savannah, Georgia 31401

ALL RIGHTS RESERVED
NO PART OF THE BOOK MAY BE REPRODUCED IN ANY FORM OR BY ANY MEANS, WITHOUT
WRITTEN PERMISSION OF THE PUBLISHER, EXCEPTING BRIEF QUOTATIONS AND REPRODUCTIONS
IN CONNECTION WITH REVIEWS WRITTEN SPECIFICALLY FOR NEWSPAPERS AND MAGAZINES.

Library of Congress Catalog Card Number: 94-071997

International Standard Book Number: 0-9641967-0-0

**TITLE PAGE: 1. BLUFFTON OYSTERMEN**
*Mounds of bleached oyster shells line the May River in Bluffton, South Carolina. This little town was one of the great oyster harvesting centers of the region. The shells were always returned to the banks of the river.*

**COPYRIGHT PAGE: 2. HARBOUR TOWN IN FOG**
*I have always been fascinated by James McNeill Whistler's paintings of fog and mist. My first paintings of this kind of weather were in watercolor; I later tried it in oil. This is a moody painting of Harbour Town surrounded by swirling fog.*

*To my mother*
HELEN TRAPIER ELLIS,
*a true Southern lady.*

5

Ray Ellis '93

# *Foreword*

"SAVANNAH, SAVANNAH"...I remember that name well when I was a boy in Pennsylvania studying the geography of the southern United States. The name rolled easily off my tongue, and in my fantasies, it evoked feelings of mystery, smells of dark, warm earth and jasmine, pictures of beautiful antebellum mansions with equally beautiful women inside, and sounds of soft, slow voices. It took me another 60 years to finally get to know Savannah and find out that my boyhood fantasies about this city were not entirely wrong. But what I didn't know as a child was that I would fall under her spell and spend some of the happiest years of my life learning all about this lovely lady.

After raising my four children in New Jersey, I moved to Hilton Head in 1972. This was my first experience with living in the Lowcountry, as this area is called, and unlike some Northerners who move South, I had no difficulty whatsoever adjusting to this unique and different part of the world. As a matter of fact, I felt very much at home. I like to think that this feeling of comfort was because I had the South in my blood. My mother's family came from Georgetown, South Carolina, and my great-grandfather, Richard Shubrick Trapier, was rector of St. Michael's in Charleston for 25 years.

As a boy on my mother's knee, I would listen to her recollections of and stories about the South. And as a man standing by her bed just before she died at age 82, I remember her looking up at me and saying: "Where did the time go? I still feel like a young girl skipping down the oyster shell road." The South gets in one's blood, and it stays there no matter how far or how long one wanders.

From my point of view, the Lowcountry is a painter's paradise because it provides unlimited subject matter. In this book, you will experience my 20 years of living in Savannah and the Lowcountry through my eyes and the brush in my hand. You will see Daufuskie Island before there was any development; you will see the brick-walled gardens and side porches of Savannah; you will see marshes in every season and at every time of the day; you will see azaleas and Spanish moss and fields of wildflowers; you will see shrimpboats and oystermen; you will see huge ships going up and down the Savannah River.

When you finish this book, I hope you will also see that my love of this area remains deeply embedded in my soul. My wife and I moved from Savannah in 1992, but my headquarters and gallery are still there. Three or four times a year, we spend several days seeing old friends and revisiting all our favorite places. These trips are full of happy nostalgia for us both, because Savannah is a place where we truly can go "home" again.

—*Ray Ellis*

# Acknowledgments

GRATEFUL THANKS go to Esther Shaver, my co-publisher, who kept at me to do this book; to Arthur Gordon, my friend and a native Savannahian, who wrote the introduction in a way no one else could; and to Treesa Germany, Director of Compass Prints/Ray Ellis Gallery, who runs my business and therefore my life with astounding efficiency and great good humor.    —*Ray Ellis*

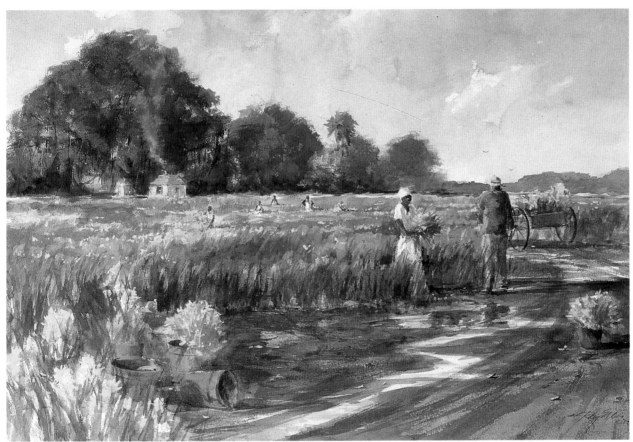

**3. DAFFODIL FARM**
*On my drives between Hilton Head and Savannah, I used to pass a daffodil farm near Pritchardville, South Carolina. The fields were carpeted in yellow in the spring. One day I made a point of stopping to capture this scene in paint as the field hands gathered the flowers for market.*

ONE STANDS in awe of Ray Ellis' talent. His great love for the Southeastern Coast is visible to all. Ray Ellis is a charmer—a great storyteller, a kind, thoughtful person. He's a guy whose success pleases everyone. I'm delighted to be co-publishing with such enormous talent.    —*Esther Shaver*

## 4. THE ENDLESS MARSH

*There are many places in the Lowcountry that give the feeling of vast expanses—you don't have to go far from Savannah to find them. Just across the Savannah River in South Carolina, the marshes seem to go on forever.*

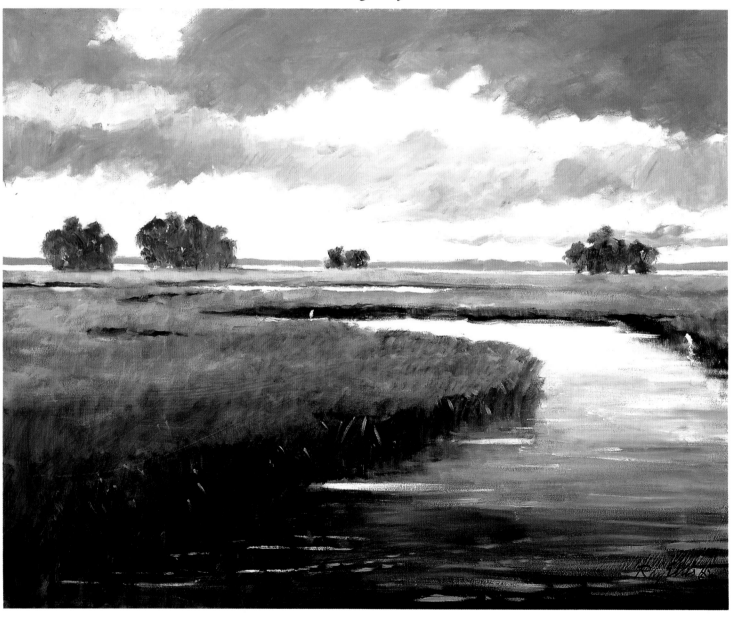

# A Very Special Kind of Place
## By Arthur Gordon

WHO can fully explain the mystery of *place*? Why is one set of surroundings memorable and another instantly forgettable? It's a question of specialness, isn't it? There has to be something arresting, something magical about the way the fragments of a given place come together to make up the whole.

And there's another mysterious thing about place: surroundings condition people. Climate and history, tradition and legend, manners and mannerisms, perhaps even the quality of light that falls upon the earth—these things leave tiny traces on the minds and hearts of those who live inside certain invisible boundaries. And if the specialness is strong enough, one can sometimes meet a stranger and say unerringly, "Why, yes, you must be from there!"

In the southeastern part of the United States there is a small region where this quality of specialness is very strong indeed. It runs along the Atlantic seaboard, seldom reaching more than twenty miles inland. Salt water is the dominant element here; there's not a hill in sight. Tidal creeks and rivers wind through endless marshes, encircling forested islands. Emerald in summer, amber in winter, the marshes stretch to the horizon, giving the eye (and the soul) a chance to expand.

Near the center of this region lies a city, modest in size, with a sweet-sounding name. It's not easy to capture the essence of Savannah either on canvas or in words because the images it offers are so varied and sometimes so apparently contradictory. What does a blaze of azaleas in a well-tended garden have to do with gray-faced cabins sitting forlornly along an unpaved street? What connection is there between the shining towers of an ultramodern bridge and the sagging belfry of an old abandoned church? An artist might say that the common denominator is beauty, for those who can perceive it. A writer might say that each of these things makes a contribution to a pervading mystique and each has something important to say to anyone willing to stand still and listen.

It takes time to create such a mystique . . .

On a soft February day in the year 1733 a handful of English men and women led by General James Edward Oglethorpe scrambled up a steep bluff on the south bank of the Savannah River where they set about establishing the thirteenth and last of His Britannic Majesty's colonies in the New World. In the years since then Savannah has known wars, pirates, blockade, siege, earthquakes, hurricanes, yellow fever, and occasionally a fragile prosperity. None of these visitations ever ruffled Savannah for very long. They merely strengthened her conviction that time will take care of everything, if you just let it.

Anyone who comes to Savannah today looking for uniqueness doesn't have to search very far. The City Hall with its glittering dome (real gold-leaf, no less) stands with its back to the tawny river, not thirty yards from the spot where Oglethorpe pitched his damask tent. If you start there and stroll leisurely south along Bull Street (don't hurry!) in the next hour or so, you will accomplish one of the most remarkable promenades in America, or indeed in the world. In stunning succession five symmetrical squares open up to you, each with its own heroic monument, its own landscaping, its own mood, and its own history. It's almost as if the city were welcoming visitors with free tickets to a wonderful five-act play.

Given Savannah's warlike past, it's not surprising that four of the five monuments in these squares pay tribute to soldiers. The fifth commemorates Georgia's first West Pointer who, dismayed at not being able to find a war to fight, had to content himself with building a railroad instead.

Softening this martial atmosphere are the mellow nineteenth century mansions and town houses that cluster around the squares. Then there are the serene houses of worship. On the left as you walk along is the classic facade of Christ Church, the "mother church" of Georgia. On this site in 1736 a young minister named John Wesley started what is said to be the first Sunday School in the world. It flourishes still. Wesley was not the most popular man in town; Oglethorpe in particular found him self-righteous and exasperating. When finally he left the struggling colony (in something of a hurry), the man destined to be the founder of Methodism considered his ministry in the New World a failure.

A bit farther on is the soaring spire of the Independent Presbyterian Church whose organist, Lowell Mason, is remembered as the composer of *From Greenland's Icy Mountains*. He also wrote *Nearer, My God, to Thee*. An English tourist would feel at home here; the building is a close copy of a Christopher Wren church in Trafalgar Square. Next comes St. John's Episcopal Church, with a carillon that offers familiar hymns and sometimes, on impish occasions, *Good Night, Ladies*. If you walk past St. John's in the dusk of a winter afternoon with the antique street lamps casting pools of yellow light and the brick sidewalks gleaming wetly, it's easy to imagine yourself back in the London of Charles Dickens.

One of the most noteworthy (and unsung) landmarks in Savannah is the First African Baptist Church on Franklin Square. Dating from 1858, it was built by slaves working by the light of bonfires at night, the only time they could call their own. Many were illiterate, but they were also skilled carpenters and masons whose wives carried bricks in their aprons to the building site. The church stands there today, angular and austere and uncompromising, seemingly impervious to time. The lofty nave is capable of seating hundreds of worshipers. It's impossible to sit in one of the handcarved pews and not feel the faith and pride and determination of those bygone people some of whose descendants, perhaps, sit on the City Council today.

History hangs over downtown Savannah like a thin lilac-colored haze. If you can find the time early on some summer morning, go and sit it the old Colonial cemetery in the center of town and listen for the almost-audible footsteps of the ghosts passing by. Eli Whitney, a young visitor from Massachusetts, invented his cotton gin only a few miles from where you're sitting. He never did succeed in protecting his rights to it, but it pushed Savannah into one of her transitory periods of prosperity by 1819. Horseracing's popularity was being challenged by the newly opened Savannah Theatre. Ice, unheard of luxury, was being imported from New England and offered for sale at six cents a pound. When President Madison dropped in for a visit, they threw a terrific party for him in one of the squares and gave him a ride on the newly built sail-and-steamship *Savannah*, the first of its kind to cross the Atlantic.

Six years later the Marquis de Lafayette spoke to a crowd of cheering citizens from a balcony of the Owens-Thomas house. The citizens were not cheering some four decades after that when General W. T. Sherman reviewed his victorious bluecoats in a triumphal parade along Bay Street. The dour Yankee commander must have been impressed by the city himself. He requisitioned one of its finest mansions for his headquarters and sent a telegram to President Lincoln offering the town (not that it was his to offer) as a Christmas present.

Some voices from the past still sound clearly under the overlay of time. Here's a childless widow named Juliette Gordon Low, eccentric but warm-hearted, who has just come back from England with an idea burning inside her. The time is 1912. She is telephoning her friend Nina Pape from her home on Abercorn Street, the house incidentally where Thackeray wrote part of *The Virginians*. "Nina," she's saying, "come right over! I've got something for the girls of Savannah and all the country and all the world, and we're going to start it tonight!" Start it they did, and today the Girl Scout movement does encircle the globe.

Or listen for the footsteps of Savannah-born songwriter Johnny Mercer, a blithe spirit whose laidback lyrics and wistful nostalgia in songs like *Moon River* echo his childhood surroundings. Even after he moved to Hollywood, Mercer loved to return to Savannah and wander about looking for scenes that sometimes surfaced later in his songs: a group of sunburned children crabbing from a tumbledown dock; old black checker players on East Broad Street, frozen in time, with their boards balanced on top of bushel baskets; a grizzled oysterman heading home in his mud-caked *bateau*; memories of the old Union Station, perhaps, where the trains always backed in to prove they were in no hurry.

A female admirer once fluttered up to Johnny. "Oh, Mr. Mercer," she said breathlessly, "don't you think Savannah has the most tremendous potential?" "Sure does," drawled the author of *Lazy Bones*, "and potential's the way we aim to keep it, honey." So far, they have.

**5. BLUE HERON**

The old colonial cemetery is a good place to commune with the ghost of a departed duelist or a Royal Governor, but it's not the most beautiful burying ground in town. That distinction probably belongs to Bonaventure, once a plantation on the east side of the city, where a slow river glides past and streamers of Spanish moss weep over glimmering tombstones. Some natives say that the tranquility of Bonaventure reflects the soul of Savannah. Maybe so. In any case, around Easter-time when the trees are full of the purple smoke of wisteria and dogwood gleams against green shadows, it does seem like a peaceful ante-room to eternity, a good place to rest until you know which way you're supposed to go.

Clustered around the city are small time-mellowed river communities with easy-going names: Isle of Hope, Thunderbolt, Coffee Bluff, Pin Point, Beaulieu (pronounced Byewlee), and others. White-painted homes, some of them pillared mansions, face the river in settings of staggering beauty with camellias glowing like rubies under the massive live-oaks. Farther back from the water are more modest dwellings, some with rusted tin roofs and brick chimneys where wood-smoke curls languidly in the windless air. Here raccoons will visit you on your back porch and become quite at home if you treat them with respect and offer them marshmallows now and then.

All the rivers that wind past these communities eventually find their way to the sea. Along the barrier islands that fringe the Lowcountry are famous resorts like Hilton Head, with its careful civic planning and world-famous golf courses. But there are also miles of almost-deserted beaches, blinding white under the fierce sun, where seagulls utter their lonely cries and the graceful sea-oats nod to their own shadows. Along these islands the Spaniards planted missions long before the Pilgrims set foot on Plymouth Rock. If you walk along one of these beaches late at night, and take your imagination with you, you may see the gleam of helmets in the shadows, or the twinkle of Indian campfires on the high ground behind the dunes.

Most of the year the ocean water is so temperate that a lazy swimmer can stay in it for hours. Of course, like life, it has its hidden hazards. If you're standing knee-deep in the warm surf, at peace with the world, and suddenly a length of red-hot barbed wire seems to wrap itself around your legs, don't panic. It's just a little sea-nettle, first cousin to a Portuguese man-o-war, giving you a friendly hello. Pay it no mind.

Despite such chancy happenings, Lowcountry natives spend a lot of time out of doors. They are canny fishermen, expert boathandlers, weatherwise sailors, skilled cast-netters who drift along the chocolate-colored mudflats at low tide and in an hour take as many shrimp as their families need. In the ranks of duck and quail and dove hunters are some of the best wing-shots in the nation. Tennis and golf are available year round. National champions seldom seem to emerge from these sports, perhaps because participation is regarded as a game, not a life-or-death struggle for supremacy. Truth is, Savannah does not care greatly whether she has a national champion of anything or not. She would rather claim that her Golf Club is one of the oldest, if not the oldest, in the country, and as evidence can point to a notice of a

meeting of the Club in the Savannah *Gazette* of September 22, 1796.

Social life in the Lowcountry may not be as lavish for the favored few as it was a century ago, but the natives still love their parties. They greet St. Patrick's Day each year with a Celtic uproar that leaves everyone pale green and has become nationally famous—or infamous. On the Saint's birthday the Hibernian Society hosts a dinner that goes back almost two centuries. The Scots and Germans have their societies too. One colorful and popular form of entertaining is the oyster roast. On a fall afternoon or a winter evening when bushels of small sweet local oysters are steamed open on sheets of metal placed over pits full of glowing coals, then spread on wooden tables and opened by guests who wear a protective glove on one hand and wield a stout-bladed oyster knife with the other, the results are messy and marvelous.

No fixed boundaries define the extent of the Lowcountry; it runs from somewhere north of Charleston to the Georgia-Florida line. If you drive south from Savannah along old Highway 17, you will come to the Midway Church, built by Puritans in the 1750's. Its congregation never exceeded 150 souls, but two of its members, Lyman Hall and Button Gwinnett, were signers of the Declaration of Independence. Go another thirty miles and you come to Darien, a town that remembers

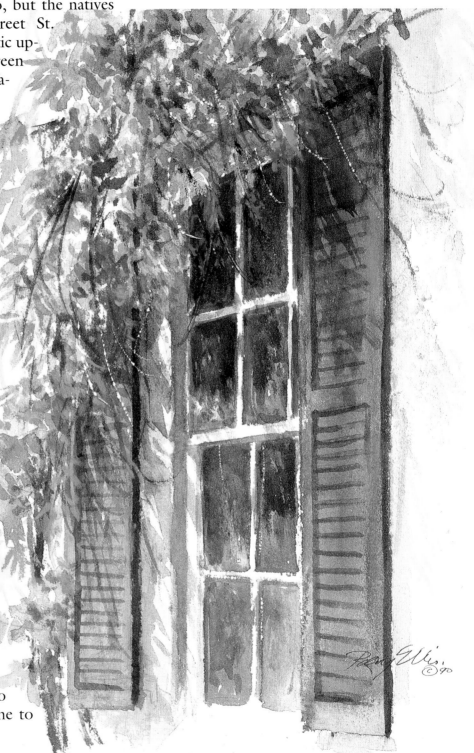

13

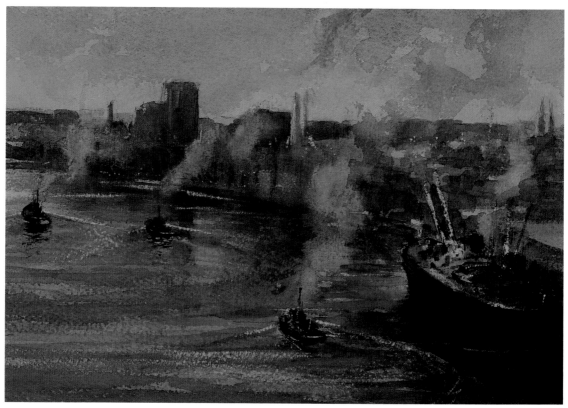

**7. TUGS AT SAVANNAH HARBOR**
*When I first set up my studio in Savannah, it was the river that first caught my interest. The narrowness of the channel made it seem more alive with traffic than most ports.*

the Battle of Bloody Marsh in 1742 where Olgethorpe's tough Highlanders repelled a half-hearted Spanish invasion. Not far away is Blackbeard Island, where the famous pirate is supposed to have buried some of his treasure. If you go there, you probably won't find it, but the fresh-water ponds do offer a seemingly endless supply of alligators, for what that's worth.

If you drive north across the river into South Carolina, you will encounter towns like Bluffton and Beaufort where the tempo of life hasn't changed much since the great rice and indigo plantations flourished two hundred years ago. "The plantation owners," wrote a visitor of those days, "are a jovial race, liberal, social, warm-hearted, hospitable, addicted to hard drinking and practical joking. They meet monthly or oftener to hunt and dine. From these feasts, no man is permitted to go home sober." To some extent the description still fits, although it must be admitted that practical joking has declined.

Older than Savannah, Beaufort is even richer in its history which goes back to the sixteenth century. Its row of ante-bellum mansions facing the water has no equal this side of Natchez. Some are so old that you can see musket-slots in the tabby foun-

**ON PREVIOUS PAGE: 6. WISTERIA**
*Our neighbors in Savannah have one of the most beautiful and burgeoning wisteria vines I have ever seen, and every year when it is in full bloom I can't resist painting it. Here the blossoms seem to frame the window.*

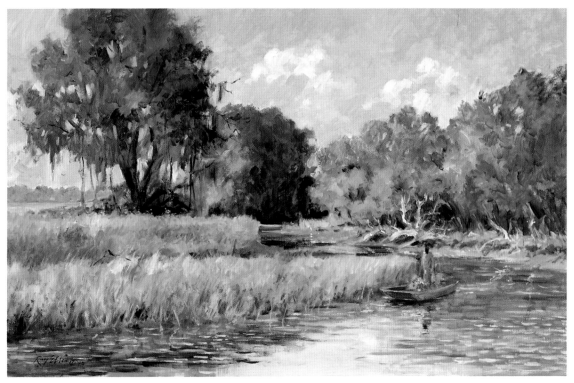

**8. STATION CREEK**

*Among the many back waters of St. Helena is Station Creek which weaves its way through the marshes with huge, dead tree limbs hanging over the eroded banks. Oystermen know every inch of these waters. I used almost every shade of green possible in the painting.*

dation, a precaution against hostile Indians. An uprising of the Yemassees in 1715 virtually destroyed the town.

Beaufort was spared destruction in the War-Between-the-States because Union forces captured it early and used it as a military base. After the war, many of the impoverished owners had to watch their homes sold for taxes. It is said that when the Fripp house was thus auctioned, a Frenchman who happened to be in town was the highest bidder. He looked at the stricken face of the grieving owner, hesitated, then walked up to him, kissed him on both cheeks, handed him back the deed to the house he had once owned, then slipped away, never to be seen again. True or not, the story has an authentic Lowcountry ring. And anyway, as everyone knows, the best stories are full of lies that tell the truth.

In scene after memorable scene, in the pages that follow, one of America's most skilled and sensitive artists tells the truth about this enchanted region. Ray Ellis knows this part of the country intimately, and loves it, and can render not only its languorous beauty but its moods, its people, its mystery and its magic.

As you turn these pages, give yourself time to study the cloud formations, the way the dust motes dance in shafts of light, the play of light on water where a tidal river coils into the sea. If you do, you will know that such things are revelations of the heart and soul of a special place. Ah, yes. Very special indeed.

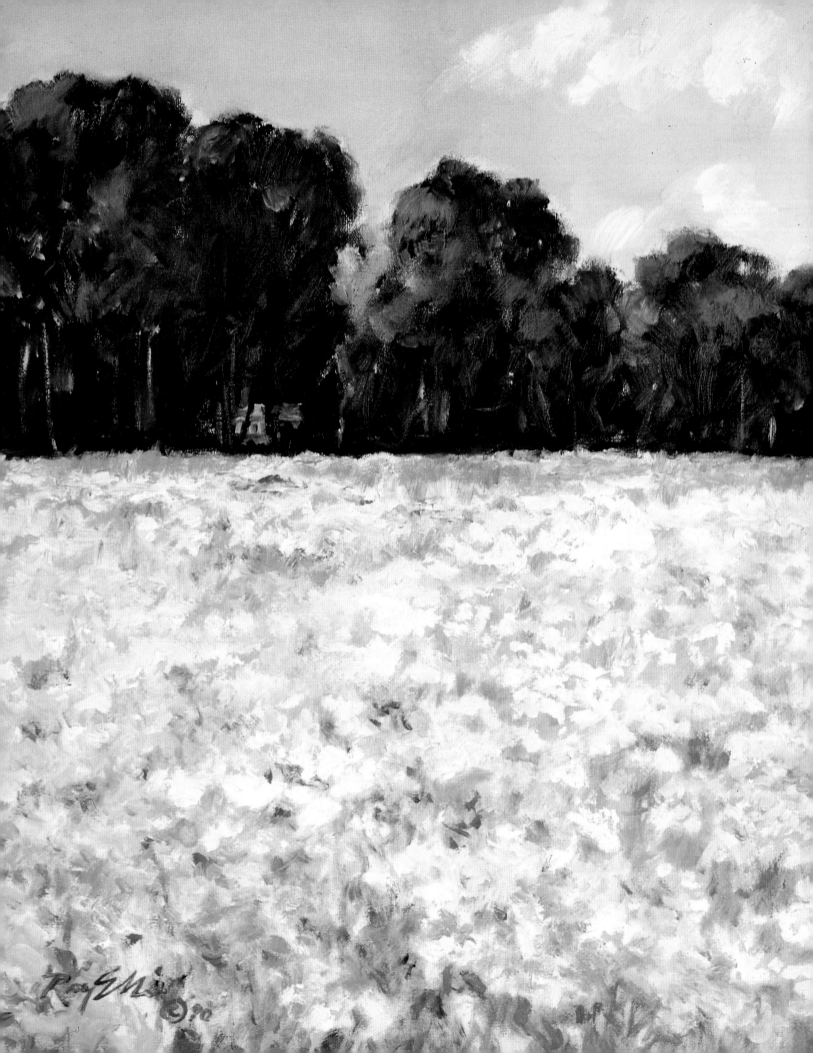

## 9. WILDFLOWER FIELD
*On St. Helena's Island, fields of pink, blue, purple, and yellow wildflowers are so abundant that they stagger the imagination. The dark tree line accents the vibrant colors.*

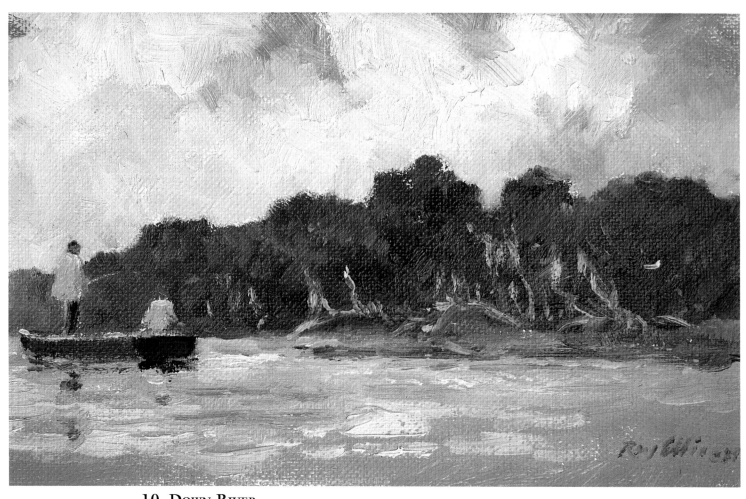

**10. Down River**
*This small oil sketch depicts two fishermen as they move down a river lined with moss-covered driftwood.*

Detail

18

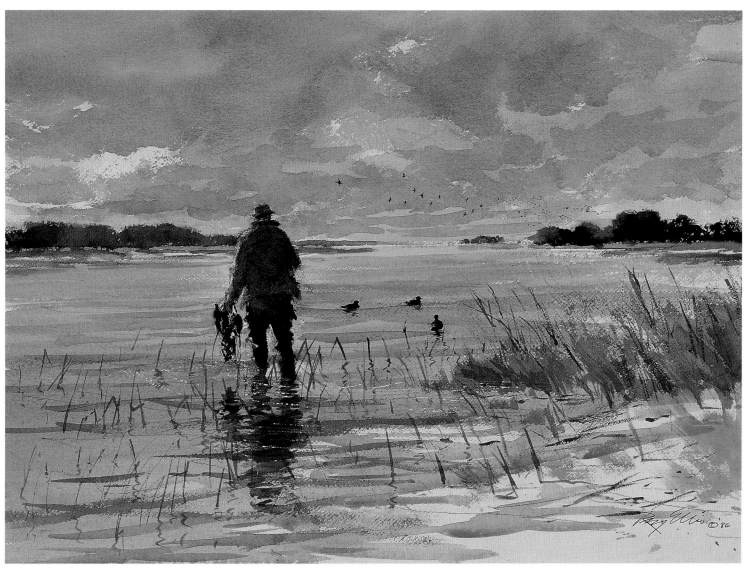

**11. WINTER MORNING**

NEXT SPREAD:

**12. THROUGH THE MARSH**
*One of my most treasured experiences was sailing through the marshes of the waterway with my collaborator on* South By Southeast, *Walter Cronkite. We talked for hours as we watched the abundant wildlife pass by. There was great feeling of isolation as depicted in this painting of a yawl wending its way through the tall marsh grass.*

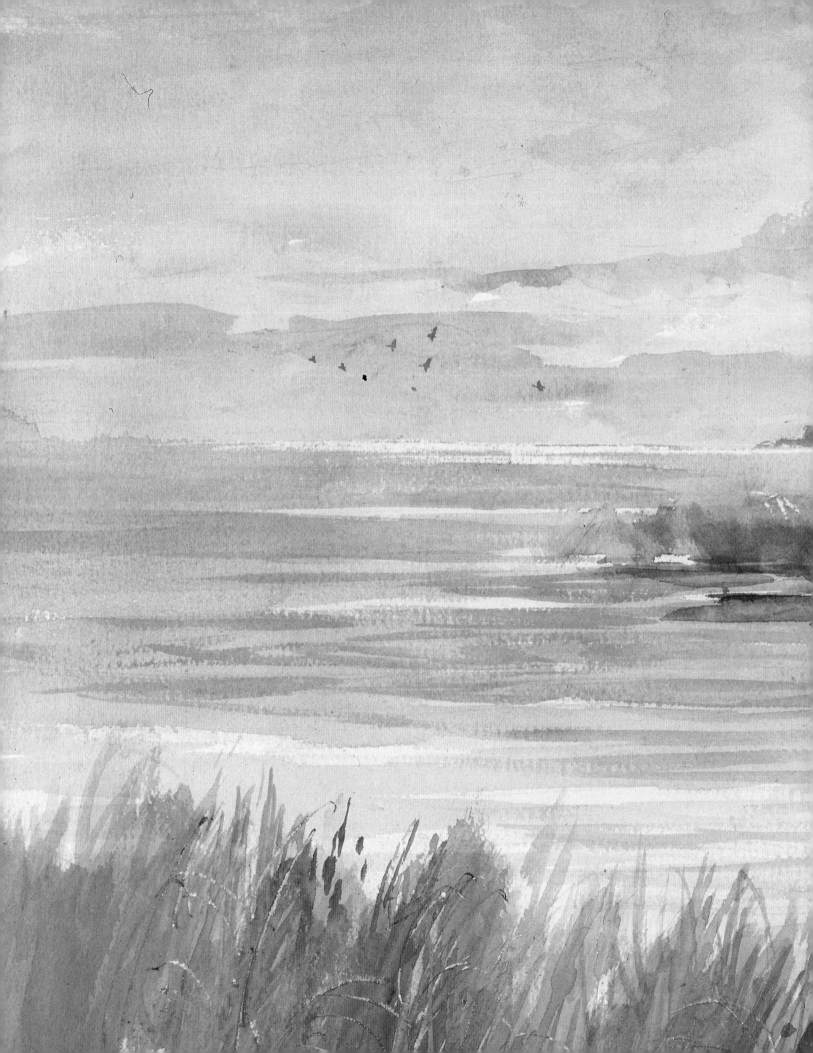

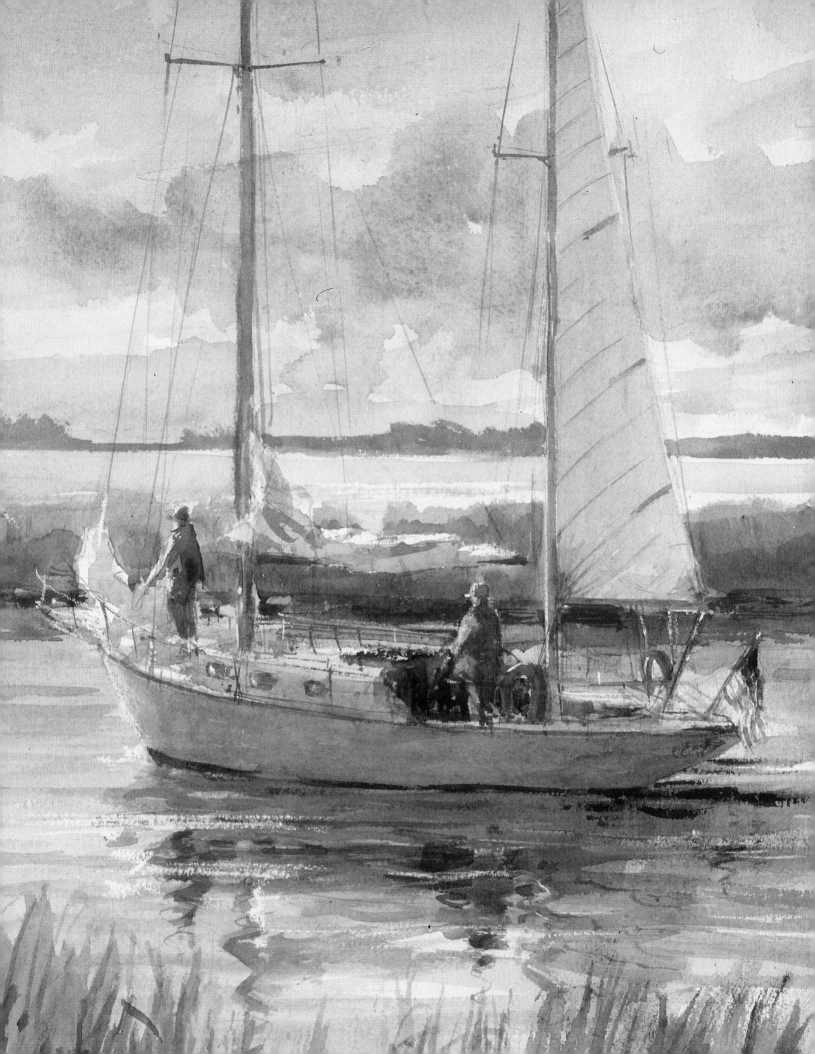

## 13. St. Helena Marsh

*Wildlife abounds in the back waters of this island. Around every bend is another view that might inspire a painting. The mood changes constantly—from low tide to high tide, on a sunny day or foggy one.*

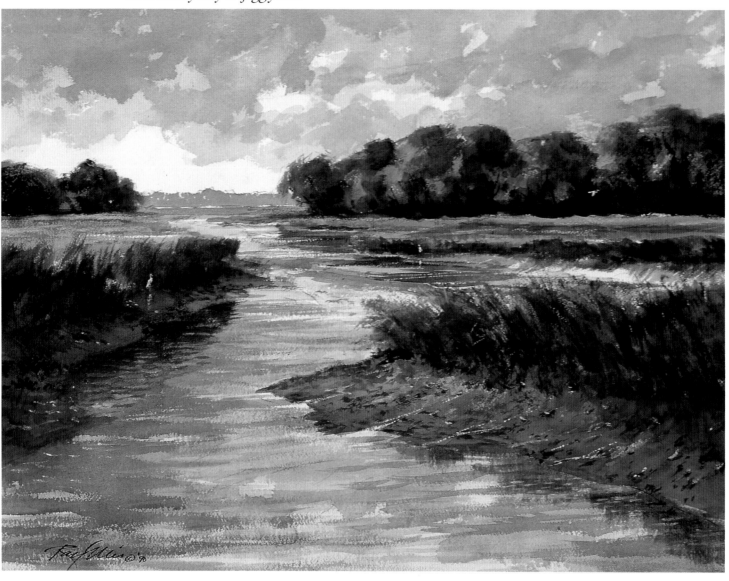

## 14. BEACH PARTY

*One winter I had the wonderful opportunity of using Walter Cronkite's 42' yawl 'Wyntje'. On one of our voyages, we sailed the barrier islands off Georgia. On some tides, we could anchor very close to shore and come in on the dinghy for an oyster roast and picnic.*

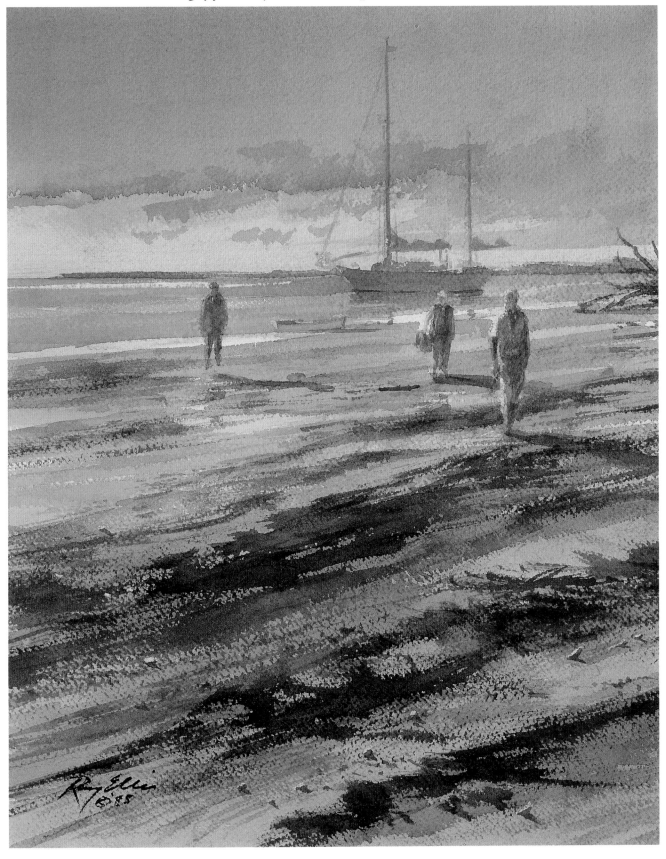

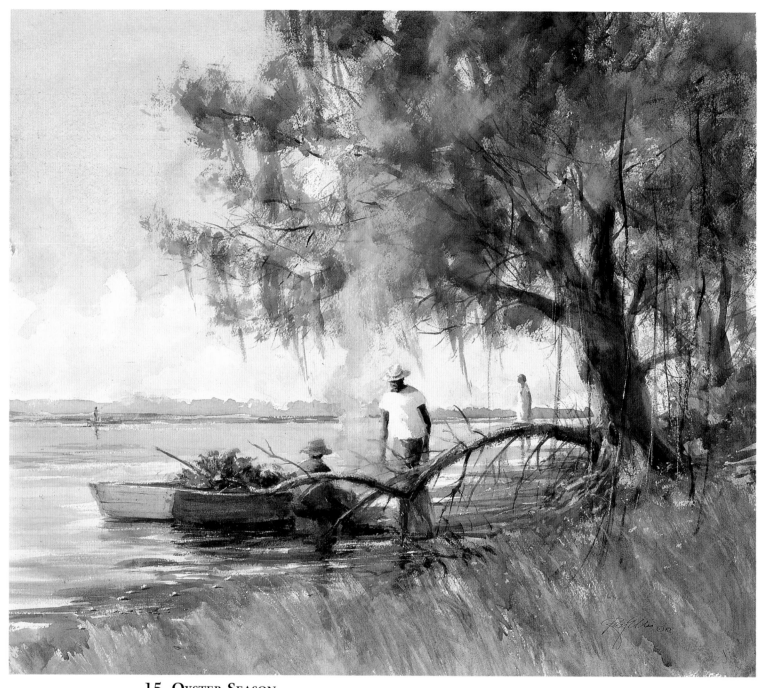

### 15. OYSTER SEASON
*Creating atmosphere or mood in a painting is very important to me. Here I wanted the viewer to be able to smell the briny odors and the smoke from the fire.*

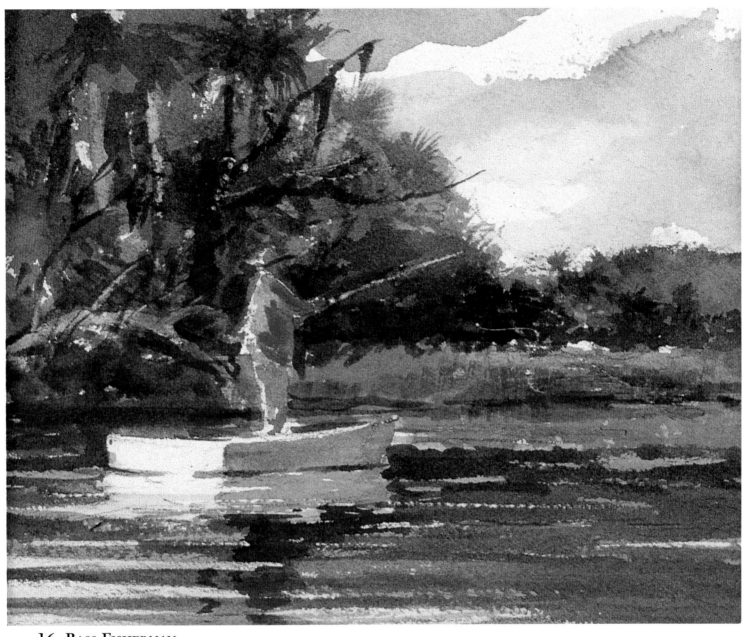

**16. BASS FISHERMAN**

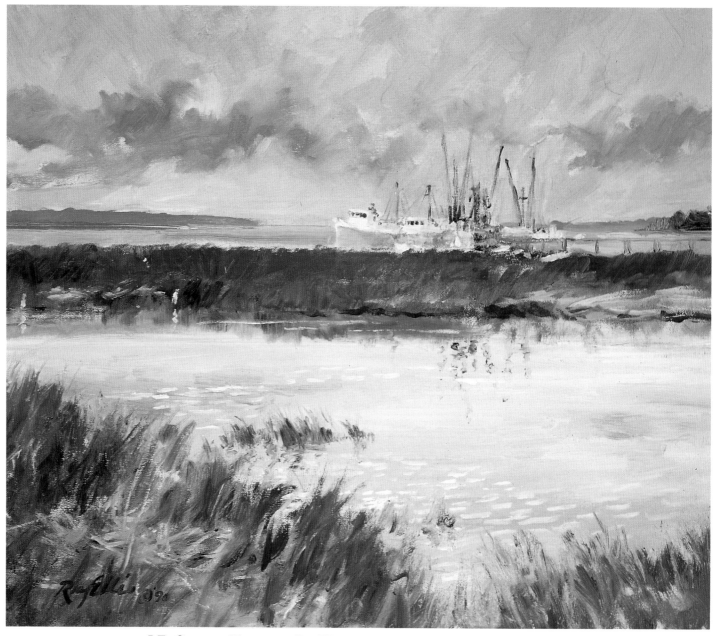

**17. SHRIMP FLEET AT ST. HELENA**

*Composition is such an important part of painting—whether to have a low horizon versus a high horizon, etc. This subject seemed ideal for the latter. The wet land alongside the river made a good foreground with the rigging of the shrimpboats reflected in it.*

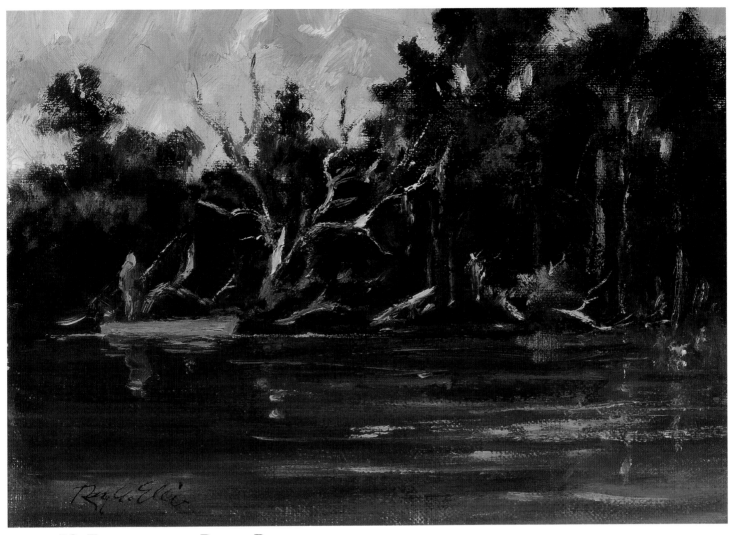

**18. FISHING ON THE PRINCE RIVER**

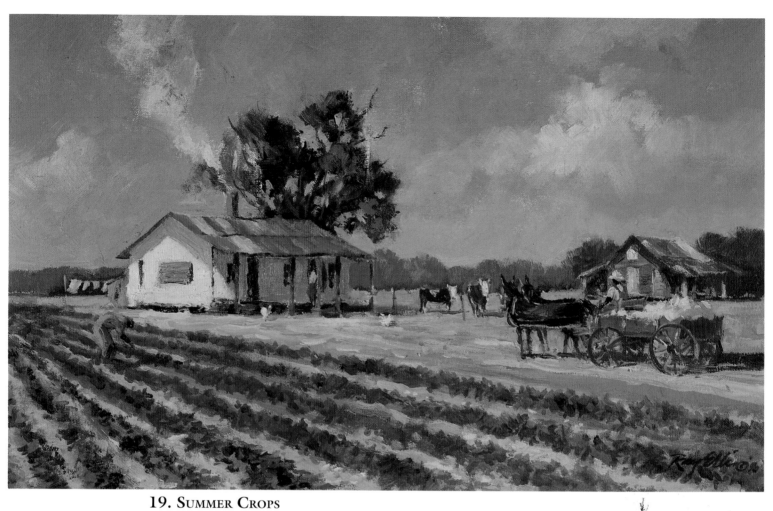

**19. Summer Crops**

**20. Frog Town**

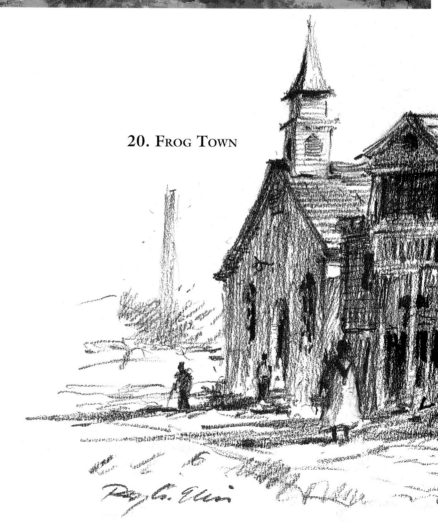

28

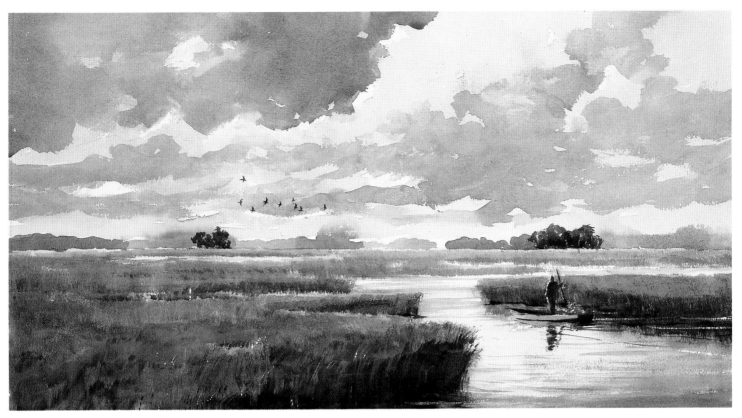

**21. SAVANNAH MARSH**

NEXT SPREAD:

**22. SAVANNAH ROOFTOPS**
*One of my favorite views of the city is from the top of the DeSoto Hilton Hotel. This painting shows the Independent Presbyterian Church where Woodrow Wilson was married. The old post office and the former Talmadge Bridge are in the background.*

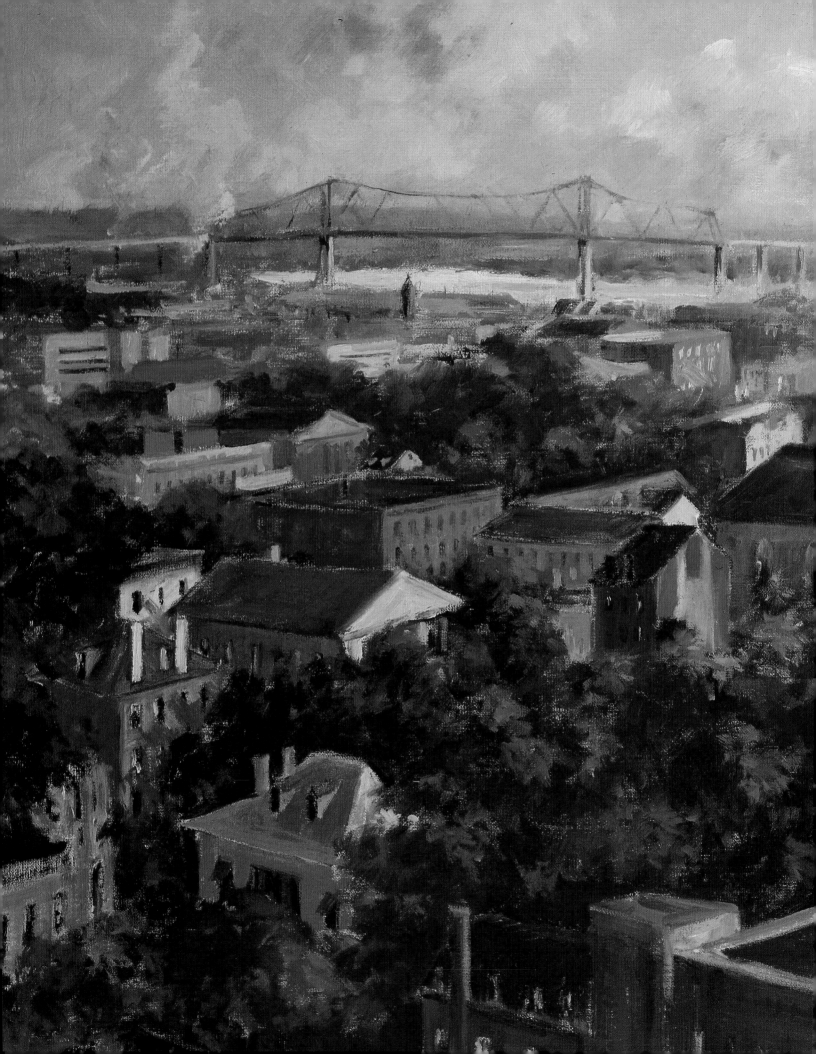

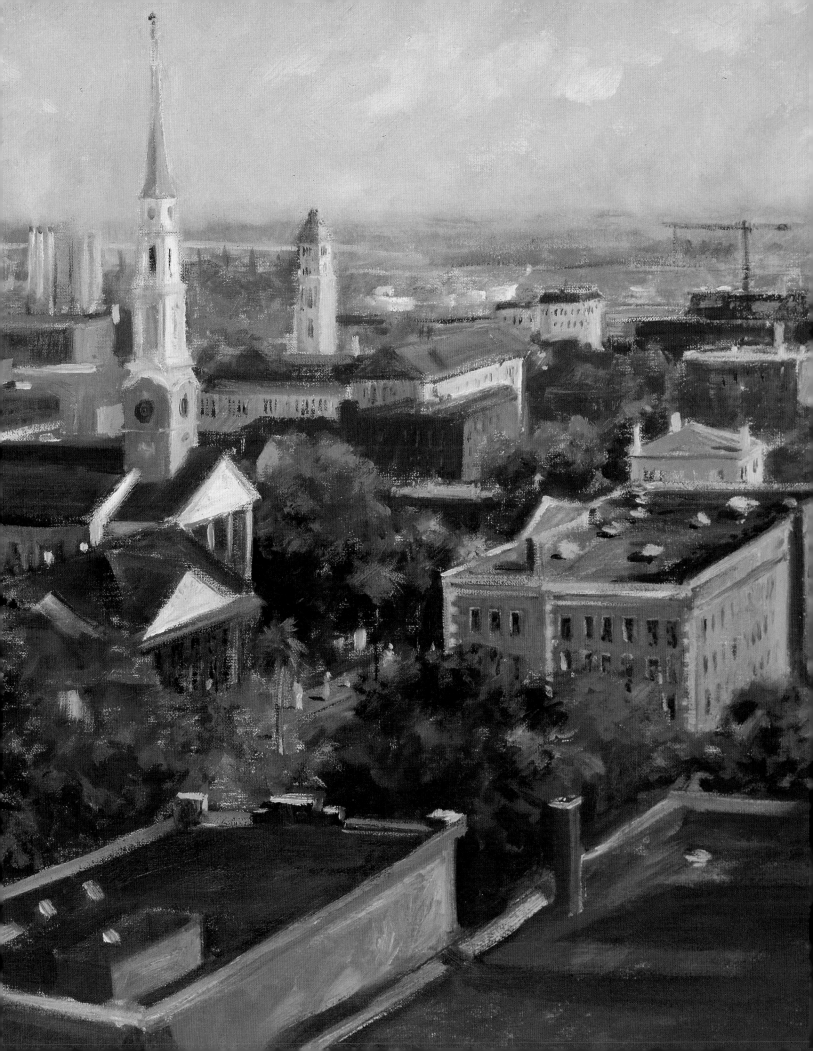

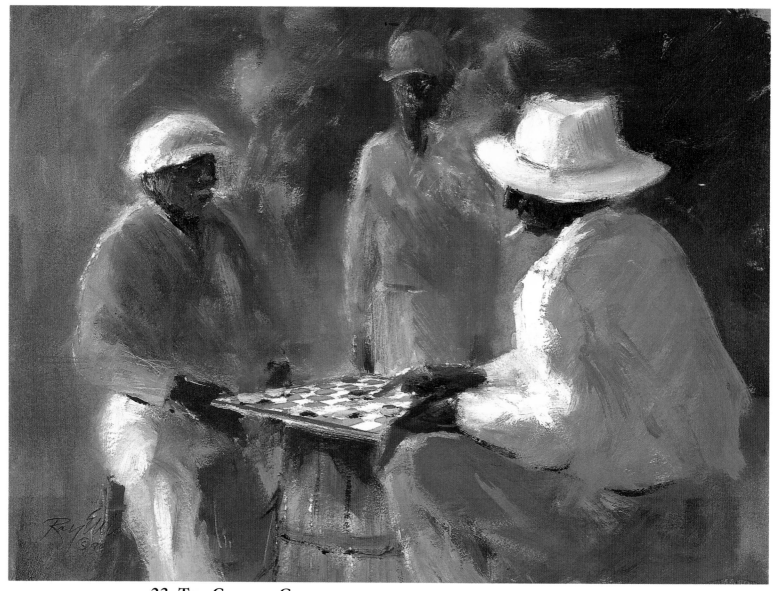

**23. THE CHECKER GAME**

*When I first came to Savannah, I was amused by the checker games being played out-doors with bottle caps on a board sitting on a basket. This was a common scene in old Savannah. It still survives today.*

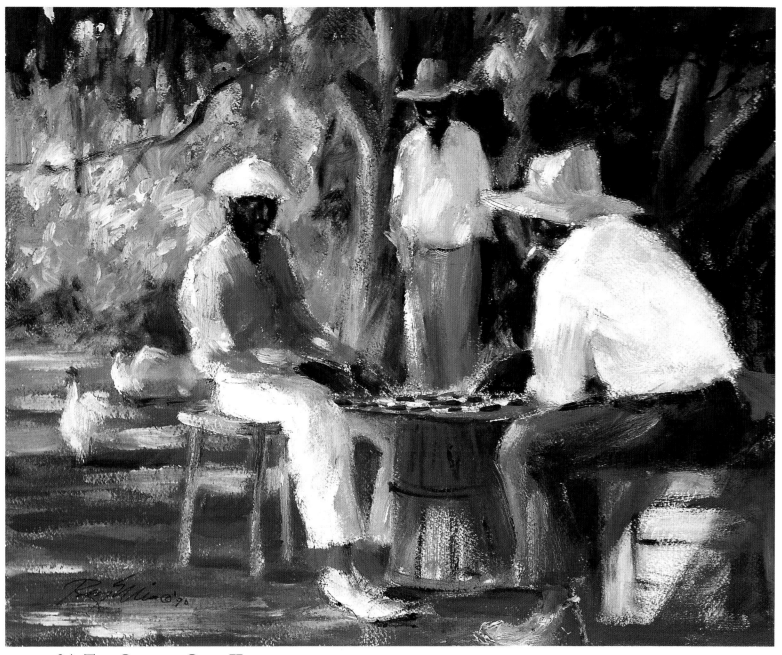

### 24. THE CHECKER GAME II
*Light, shadow, color, composition, human interest—this subject seemed to have it all. It is the sort of thing that the Impressionist in the 19th century would have loved to paint.*

NEXT SPREAD:

### 25. ON THE POINT
*Several years ago, we anchored our boat and went ashore on the north end of Blackbeard Island. The wind-bent trees and palms gave the scene the contrast it needed against the expanse of beach. This almost uninhabited island is just as it was when the famous pirate roamed the area.*

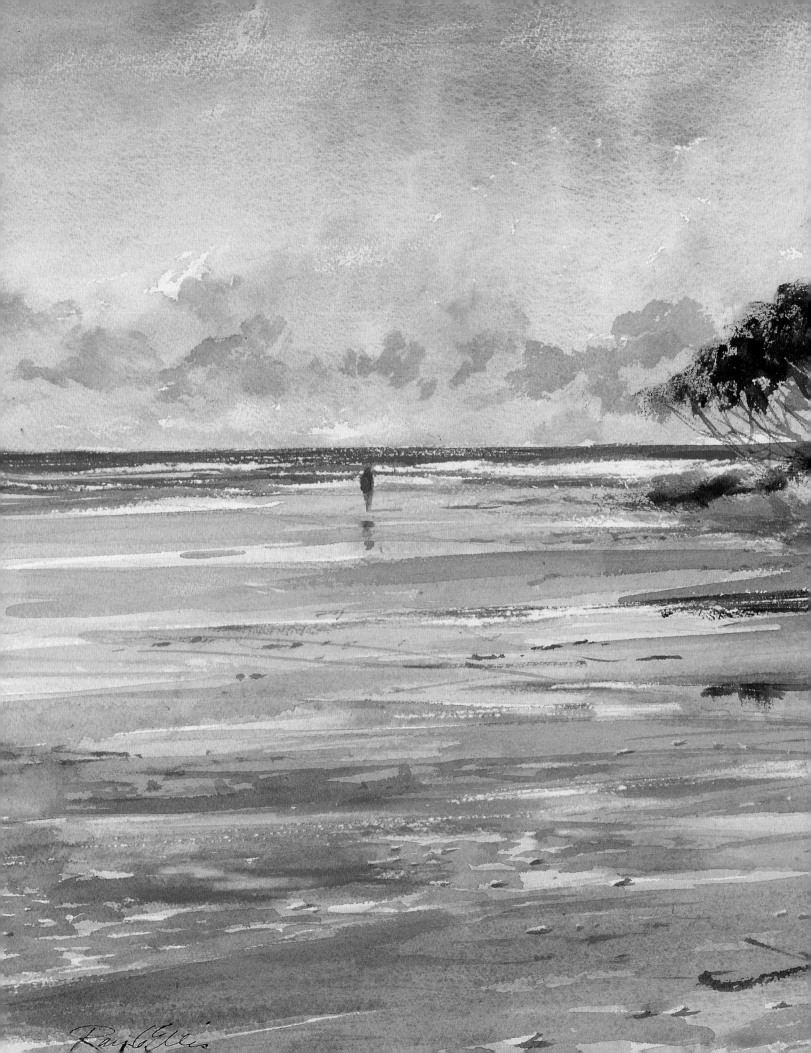

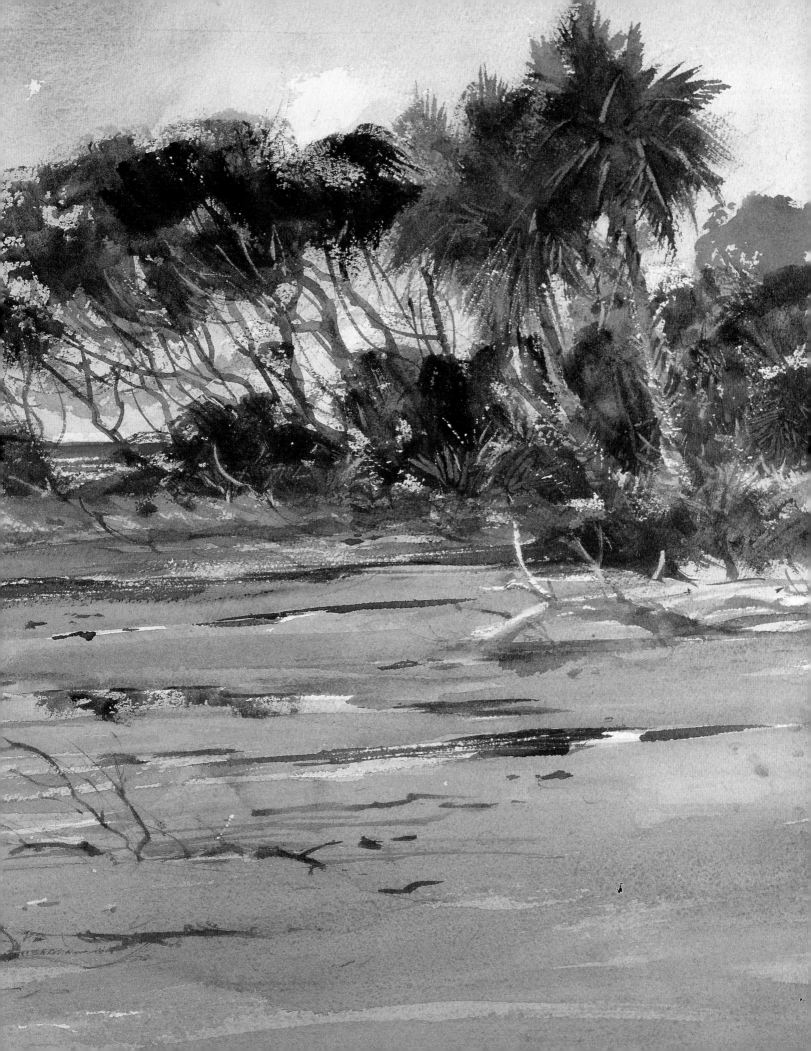

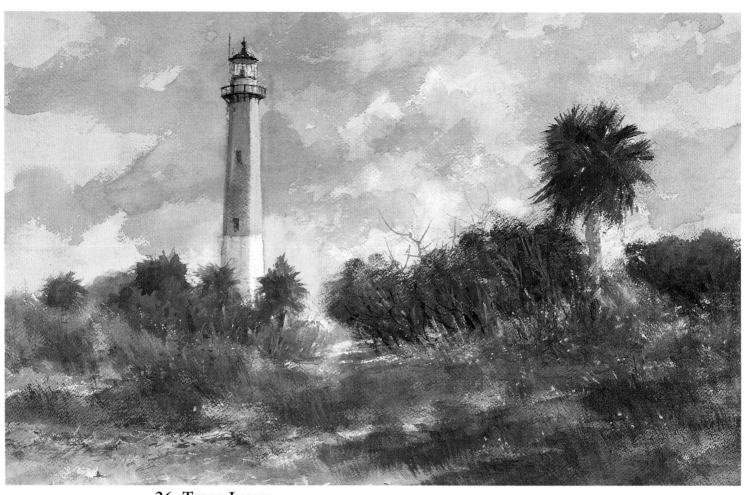

**26. TYBEE LIGHT**

*One of the oldest lighthouses on the coast, Tybee Light has guided many ships to the entrance of the Savannah River. The color of its paint has been changed many times but it remains in good condition at the north end of Tybee Island.*

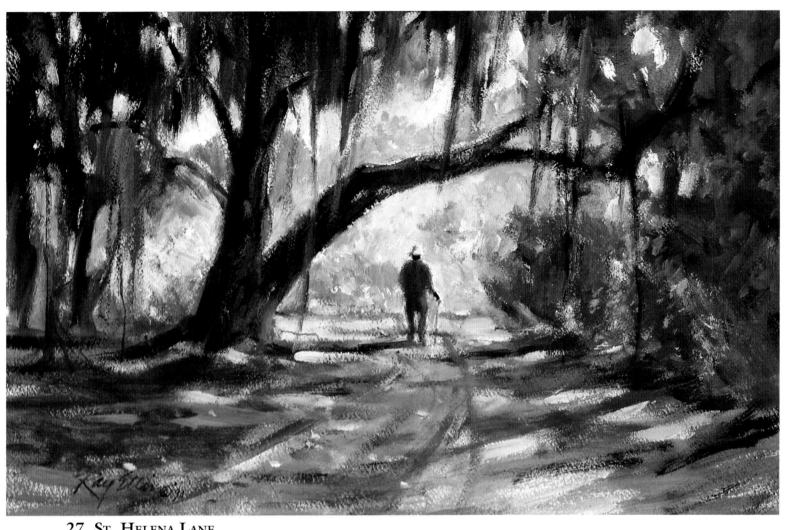

## 27. St. Helena Lane
*Live oaks and their unique character are, to me, the most typical symbol of Savannah and the Lowcountry. This one made an arch over a lonely lane on St. Helena Island.*

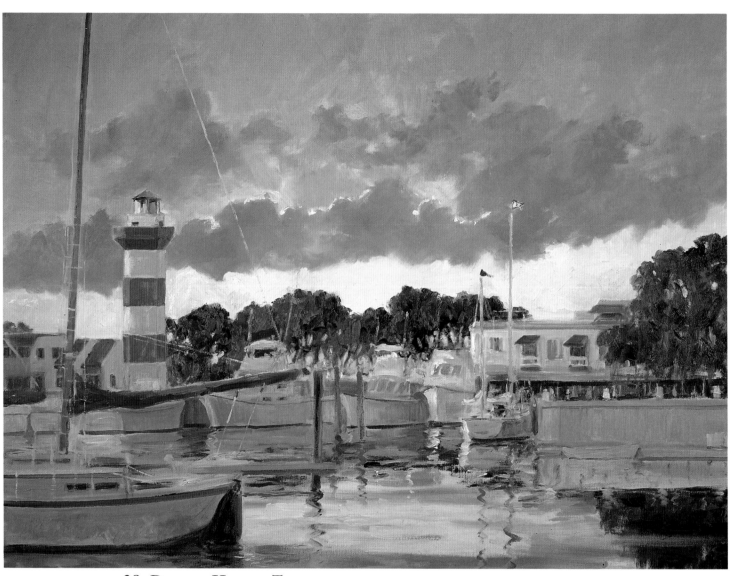

**28. DUSK AT HARBOR TOWN**

*This man-made harbor is always a magnificient sight, surrounded by ancient live oaks and filled with regal yachts. But it is never more beautiful than at the end of the day when the sun sets over Daufuskie Island.*

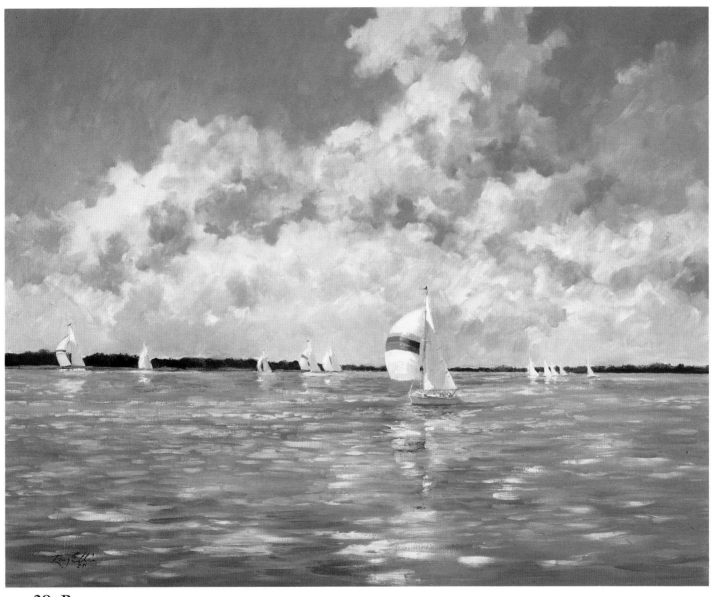

**29. REGATTA**

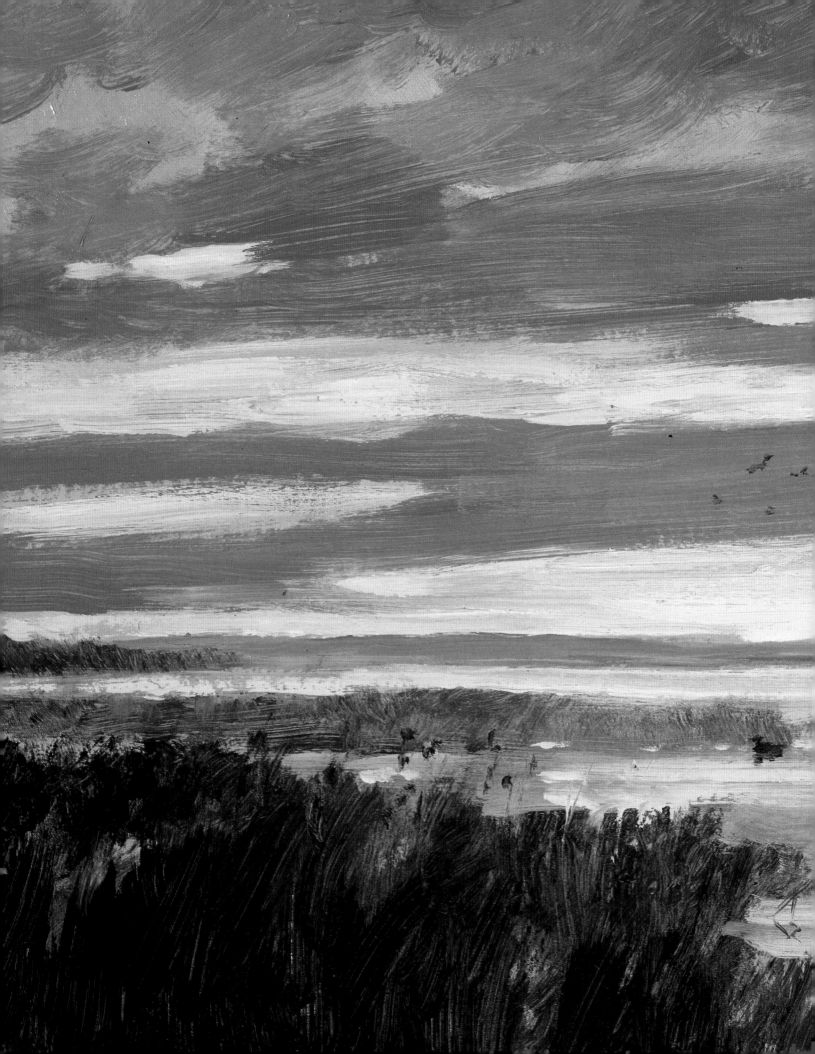

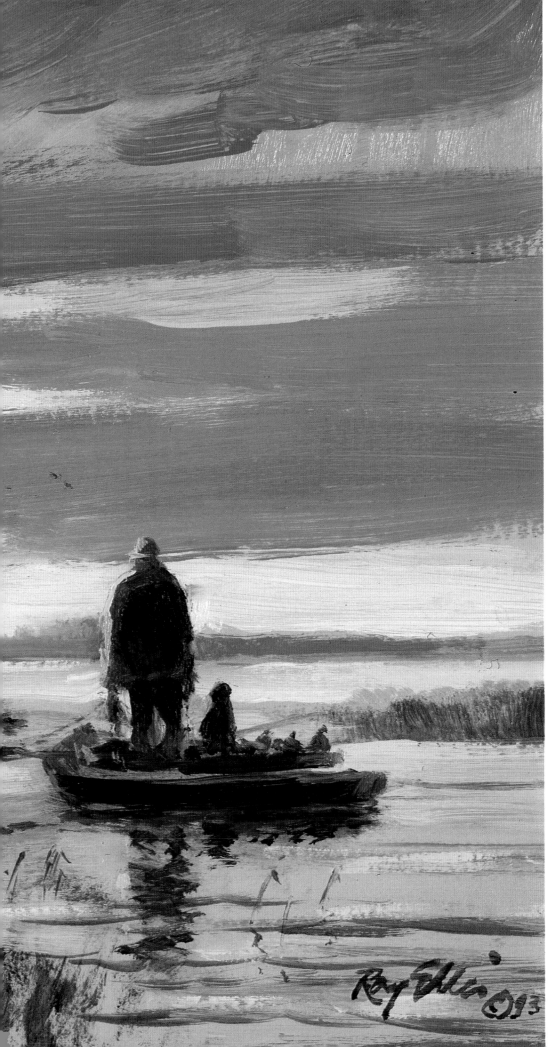

**30.** DUCK HUNTER AT DAWN
*A hunter and his black Lab watch the sunrise as he sets decoys by the marsh.*

41

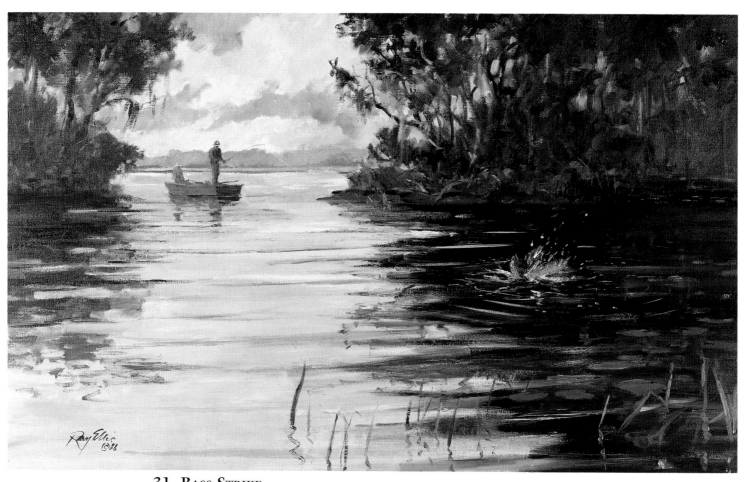

## 31. BASS STRIKE

*In the South, bass fishing is very popular in the quiet coves and creeks. In this painting, the bass is the main focus.*

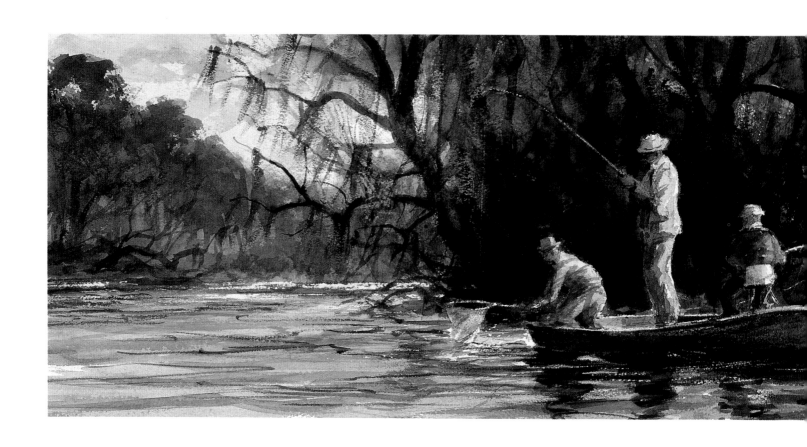

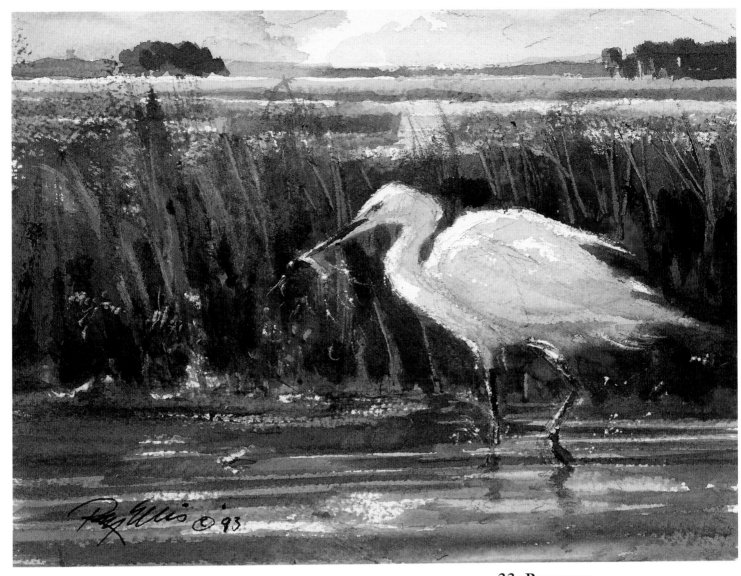

**33. PREDATOR**

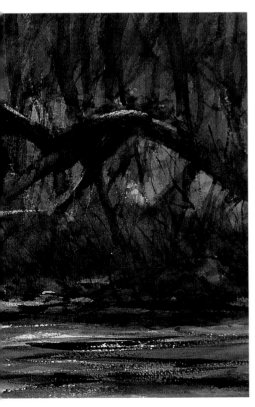

**32. SHAD FISHING**
*One of my Savannah cronies is an avid fisherman, and his tales of shad fishing on the Ogeechee River are legendary. With his help, I was able to do this painting of such a typical Lowcountry pastime.*

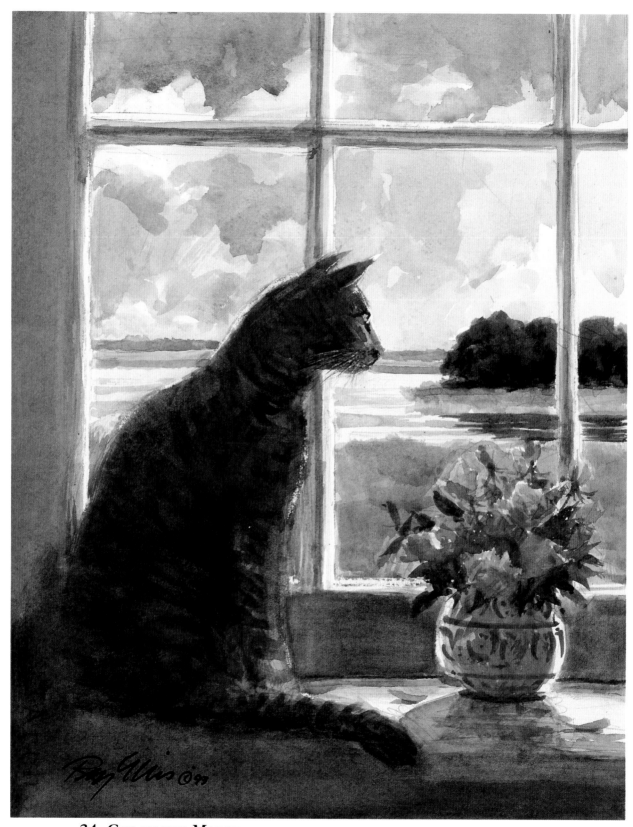

**34.** CAT ON THE MARSH

**36. Granny Smiths**

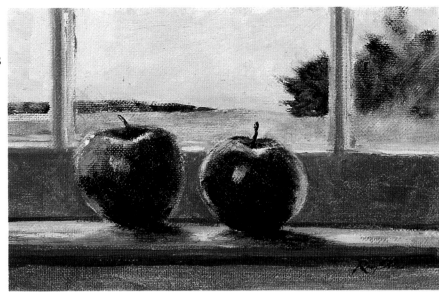

**35. Start of the Day**
*After anchoring in a quiet cove for the night, two sailboats start out on their way down the inland waterway.*

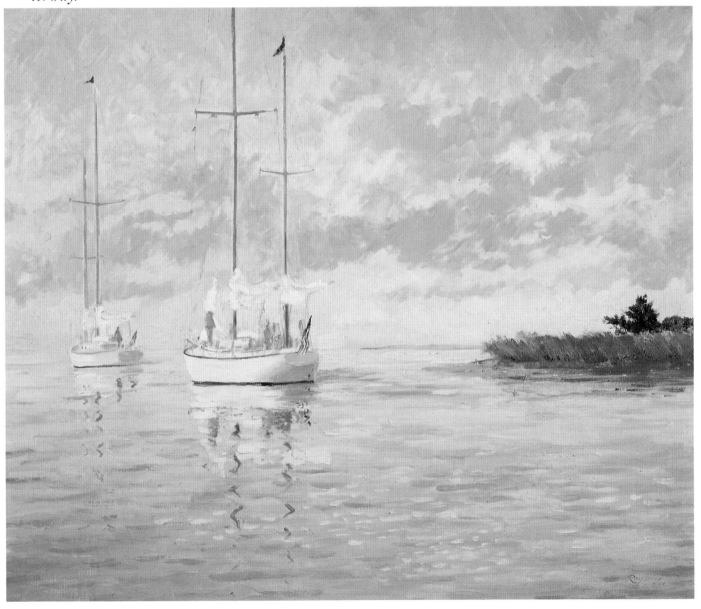

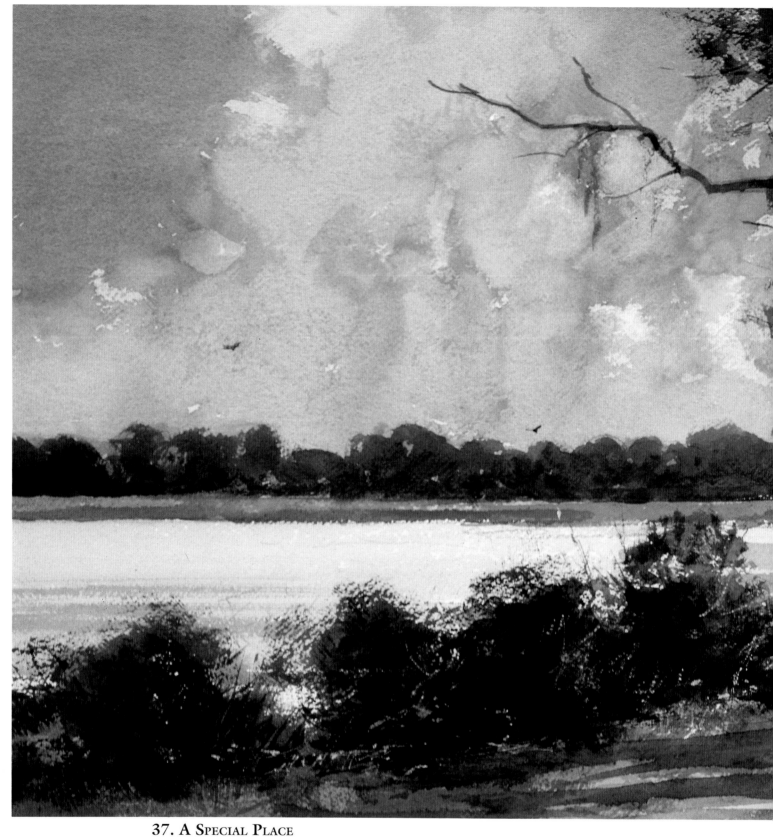

**37. A Special Place**
*Light, shadow, and smoke obviously interested me in this long, narrow composition of a quiet afternoon on the river.*

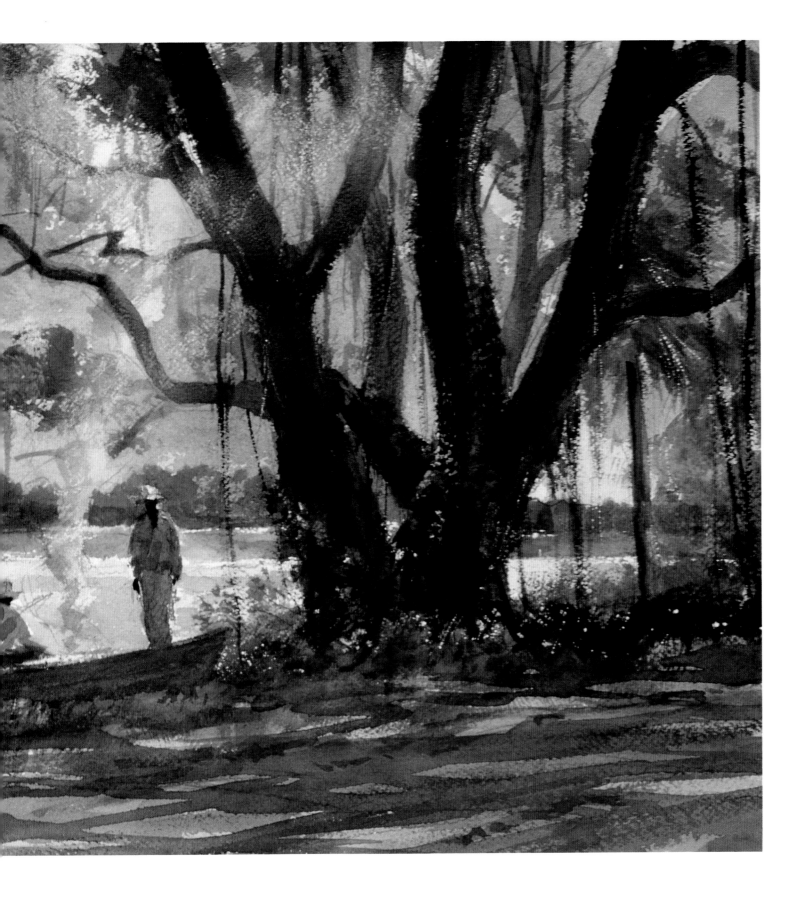

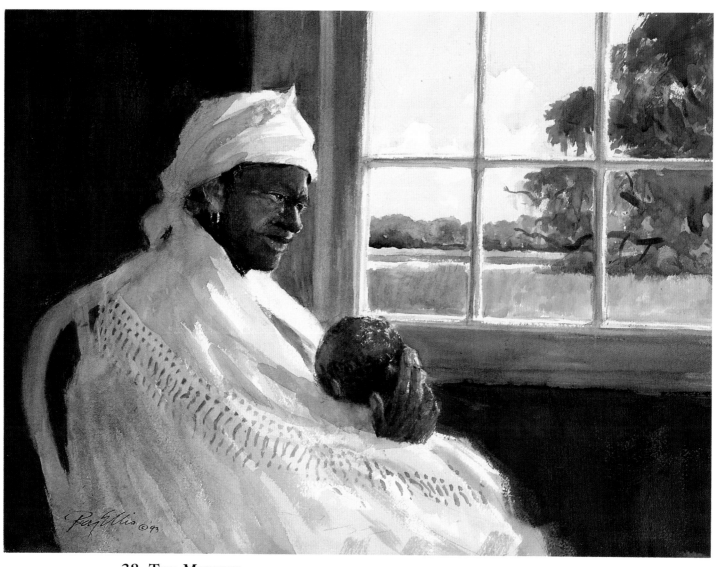

**38. THE MIDWIFE**

*In parts of the Lowcountry, many babies have been delivered and nursed by a midwife. This has been an honorable and useful profession for centuries. This midwife seems to be contemplating the troubled world that the newborn will face.*

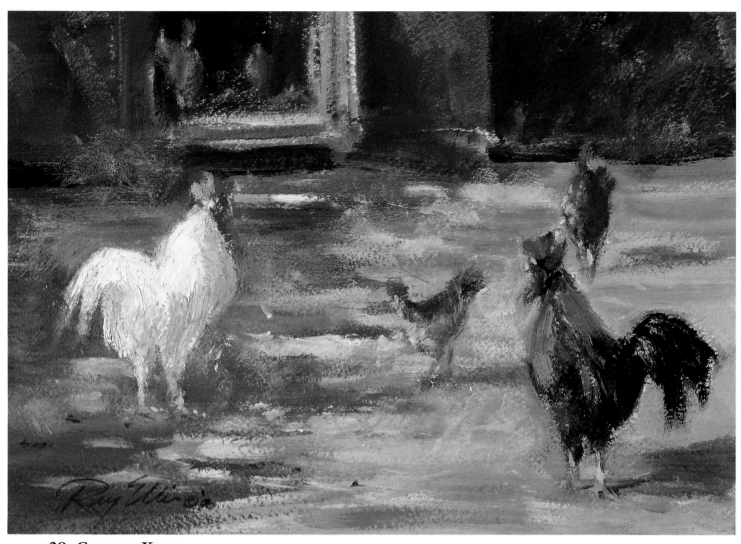

**39.** CHICKEN YARD

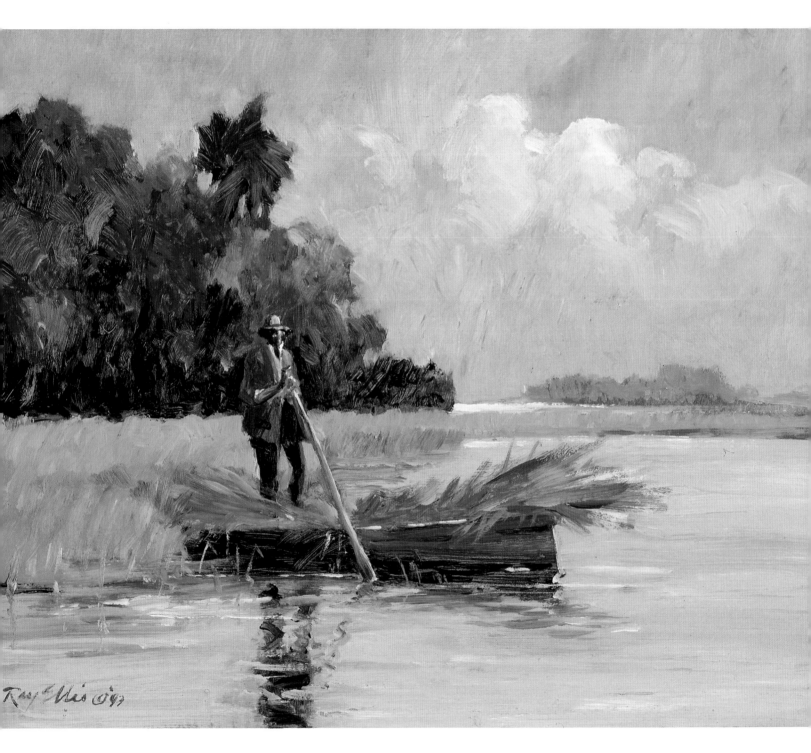

### 40. FERRYING MARSH GRASS

*Marsh grass has had many uses. It helped feed the stock; it was used as mulch; and women wove baskets from the reeds. One of the best uses from my standpoint was as a subject for a painting—a bateau being poled through the golden marshes with a load of grass hanging over the gunnels.*

50

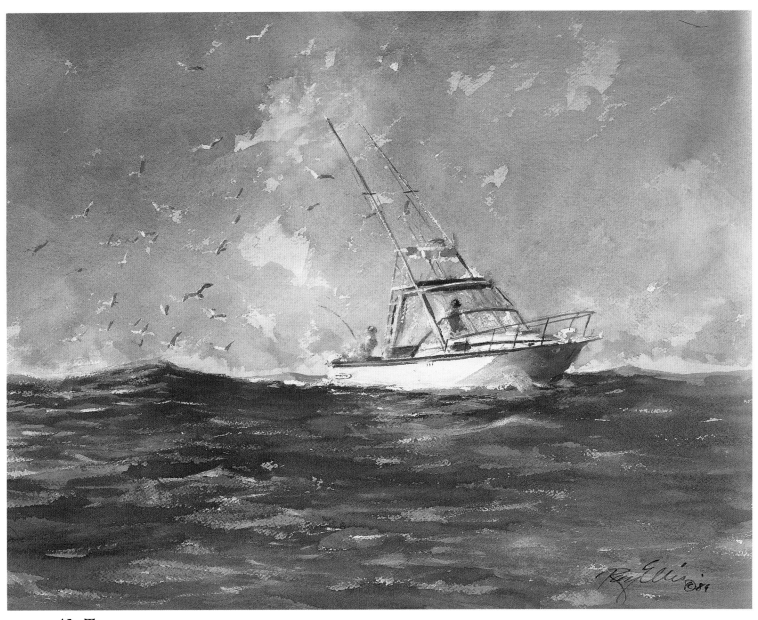

**41.** TROLLING

NEXT SPREAD:

**42.** LOOKING FOR A POINT

*I've been fortunate to have had the chance to visit some of the best quail hunting grounds in the Lowcountry. This scene of the horses, the hunters, the dogs, and the wagon is one which hasn't changed very much over the years.*

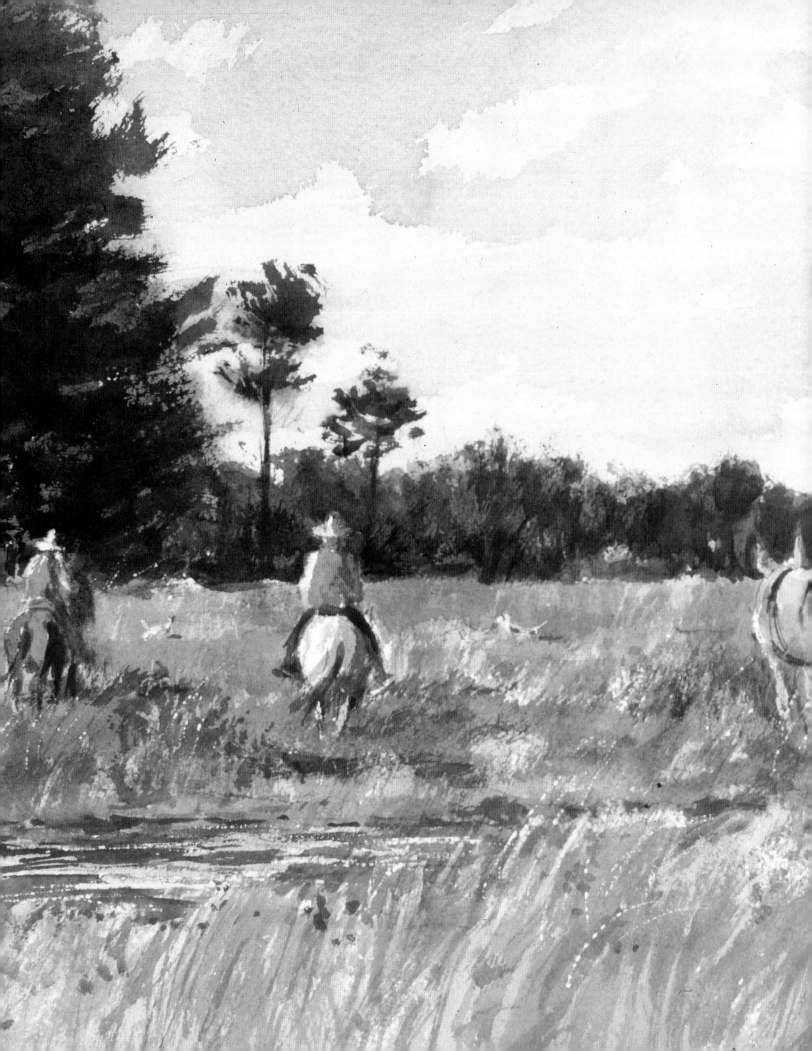

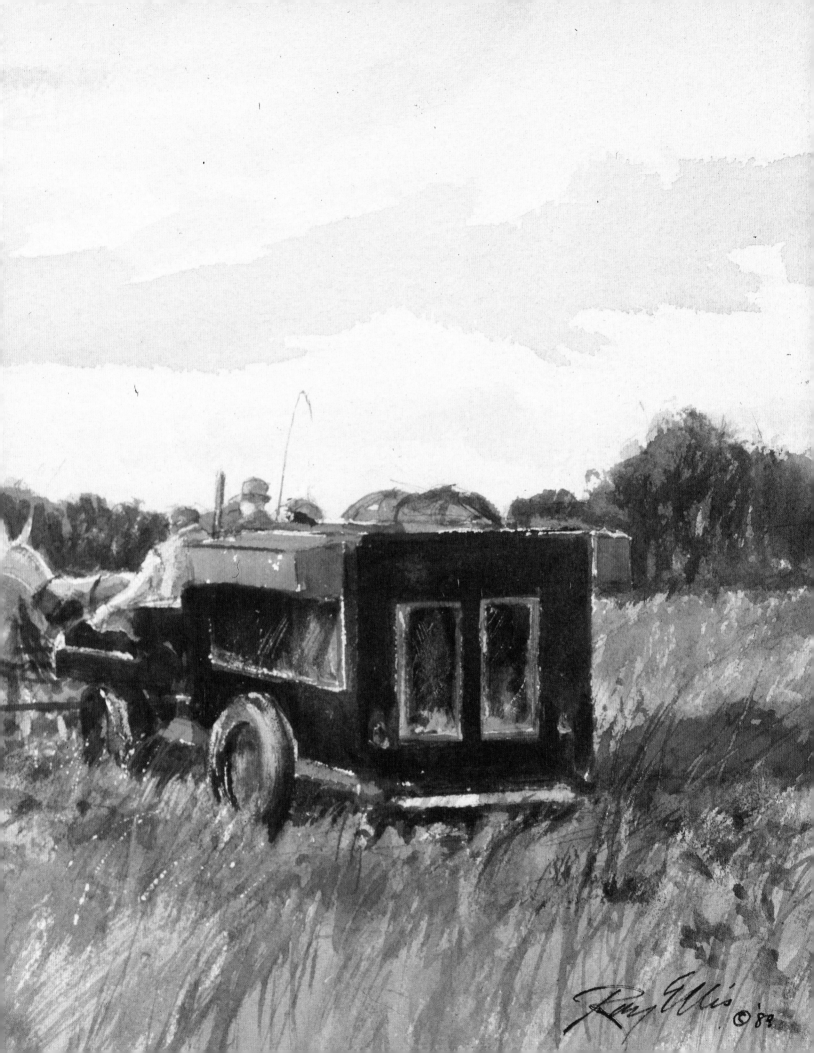

## 43. OWENS-THOMAS HOUSE

*The beautiful Owens-Thomas House is one of the finest examples of Regency architecture in America. This painting shows the balcony where Lafayette spoke to cheering crowds during a visit to Savannah in 1825.*

DETAIL

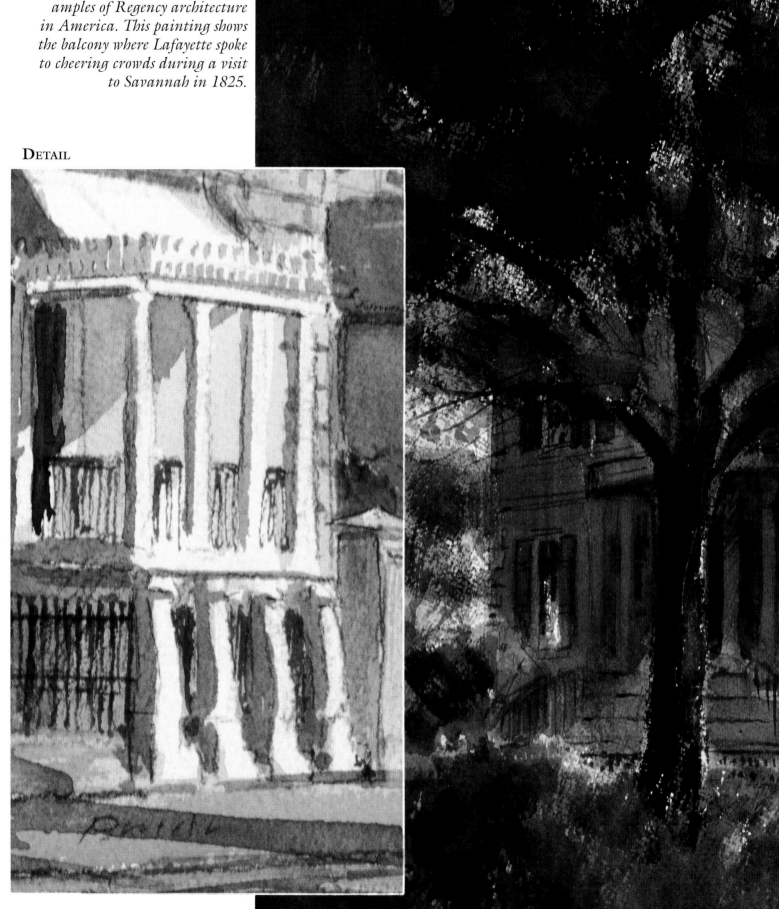

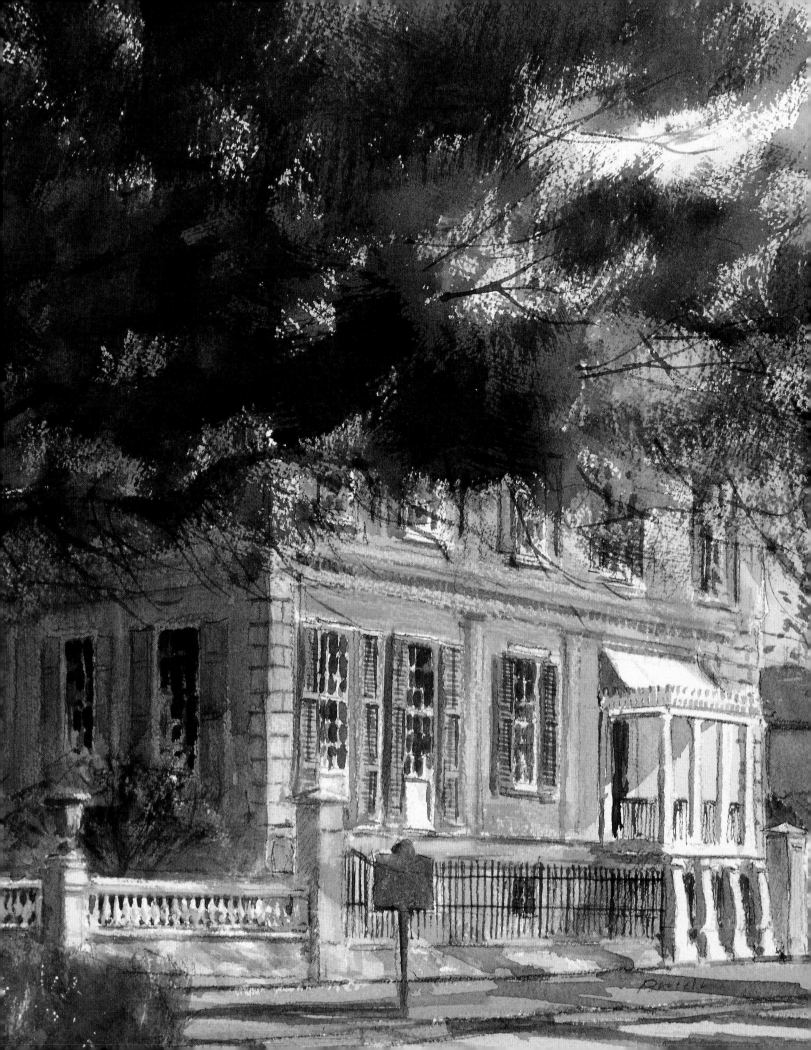

**44.** WEST FORSYTH PARK, SAVANNAH
*Each spring when the azaleas bloomed in Forsyth Park, I never failed to be inspired to paint their colorful blossoms. I thought this lovely house on the west side of the park made a good background for this landscape.*

NEXT SPREAD:

**45.** THE LIVE OAK
*Over the years I have painted many, many live oaks always hoping to find the 'special one'. Finally I did. This composition, with the light hitting the large, twisted limb and the shrimper casting his net on the shore lets the viewer appreciate the great size and majesty of this tree.*

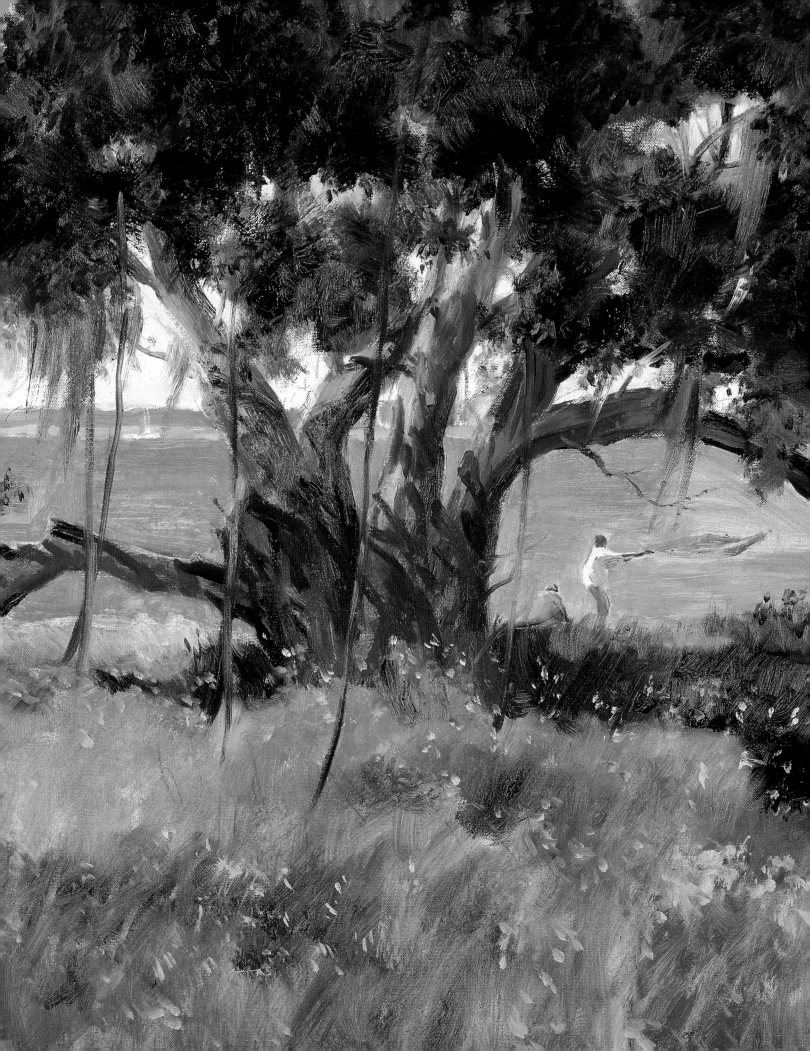

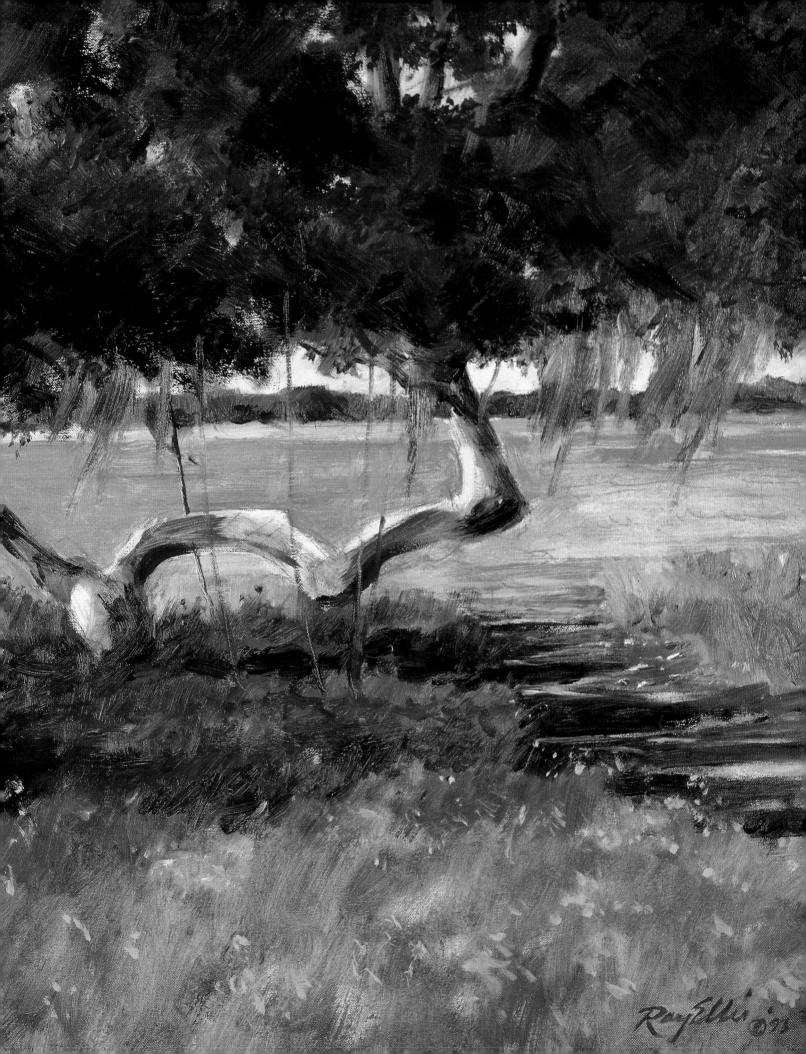

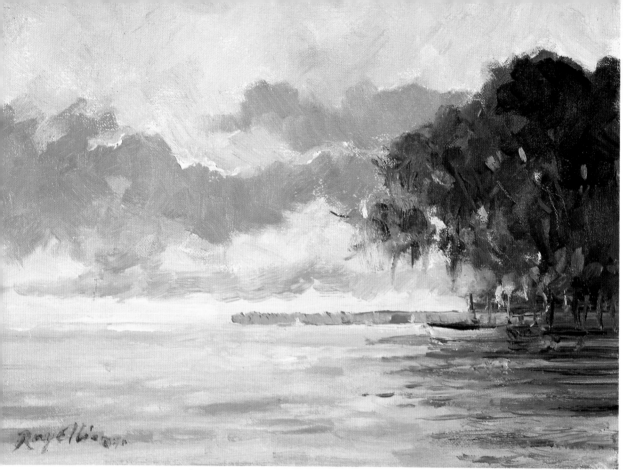

**46. Off the Point at Dusk**

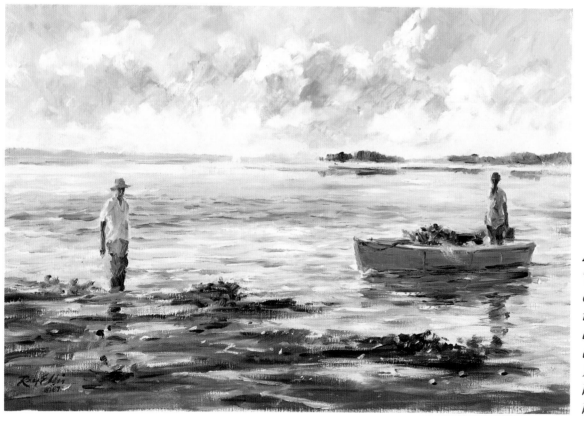

**47. On the Oyster Flats**
*The clusters of mud-covered oysters on the flats at low tide never look as appetizing as those which have been cleaned and are on a plate. Here two men work long, hard hours bringing in their harvest.*

60

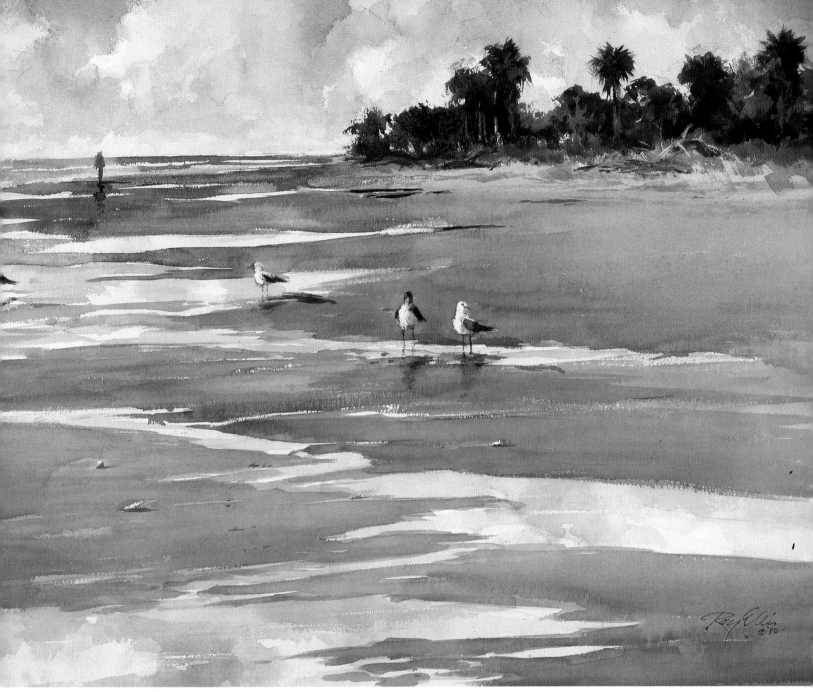

**48. BEACH REFLECTIONS**
*The beaches along the South Carolina and Georgia coasts are among the most spectacular in the world. On this one on Hilton Head Island, water remained in gullies at low tide and gulls picked at the washed-in shell life. I liked their reflections.*

### 49. DAUFUSKIE OYSTERMEN

*Ox-drawn carts were used until fairly recently to haul the oysters from the boats to the market on Daufuskie Island. I wanted to record this old way of doing things before it was too late. It almost was.*

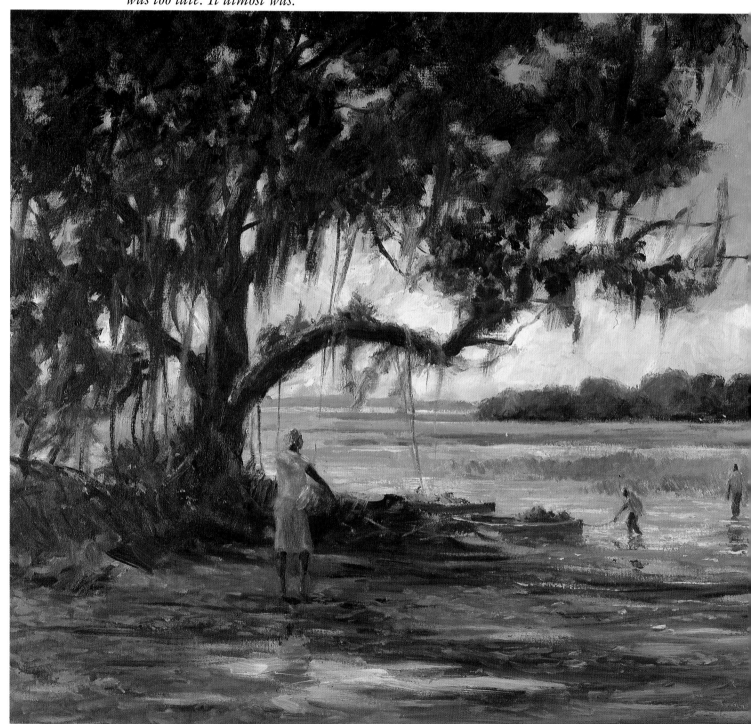

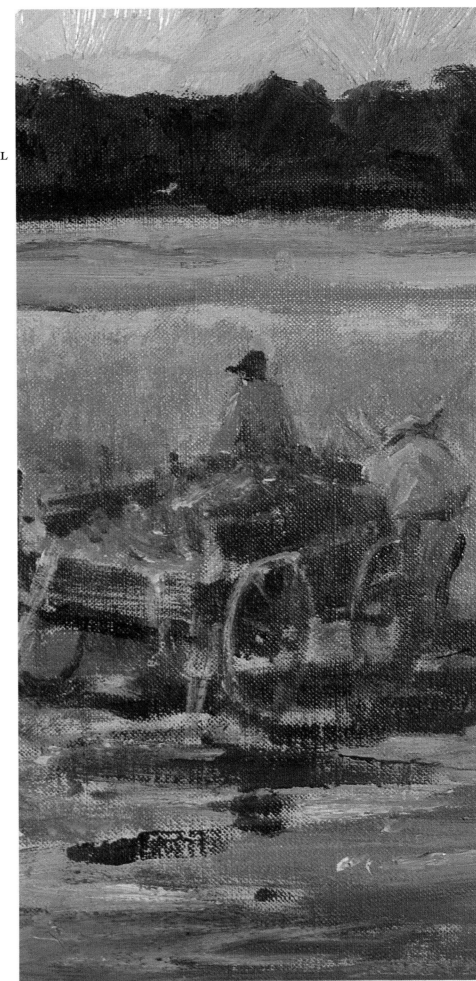

DETAIL

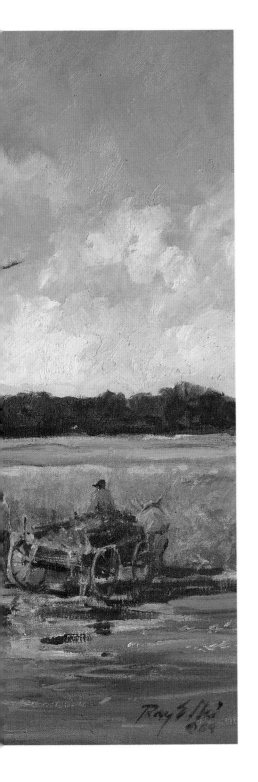

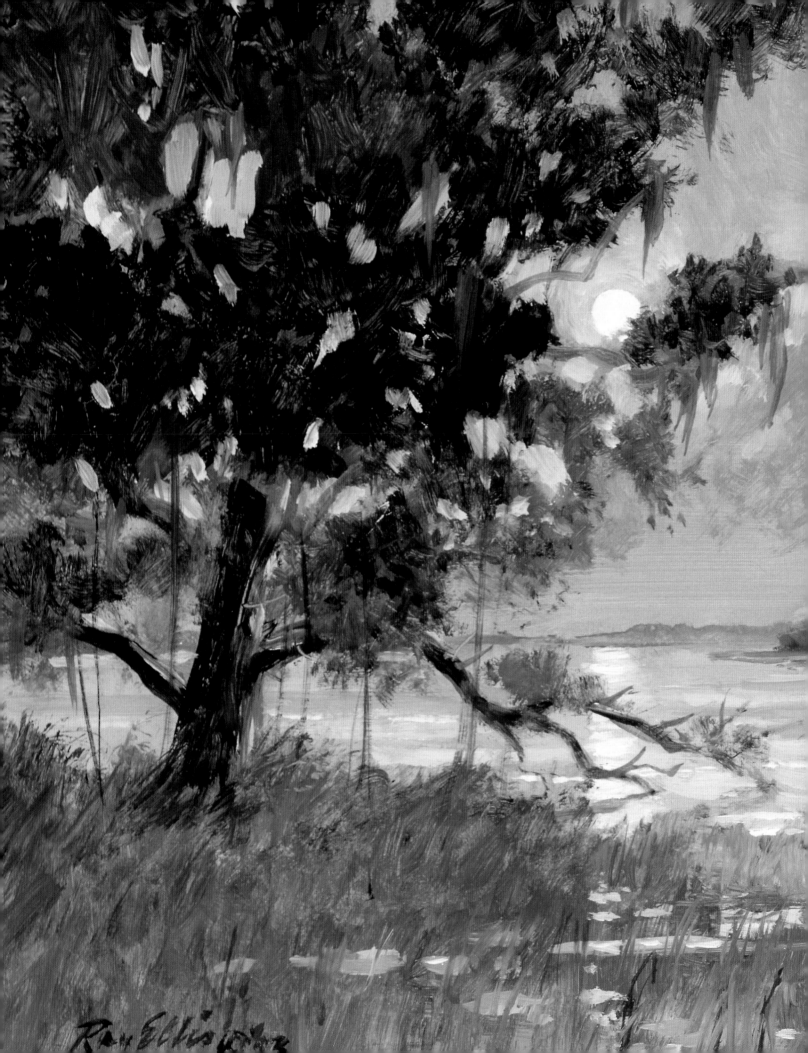

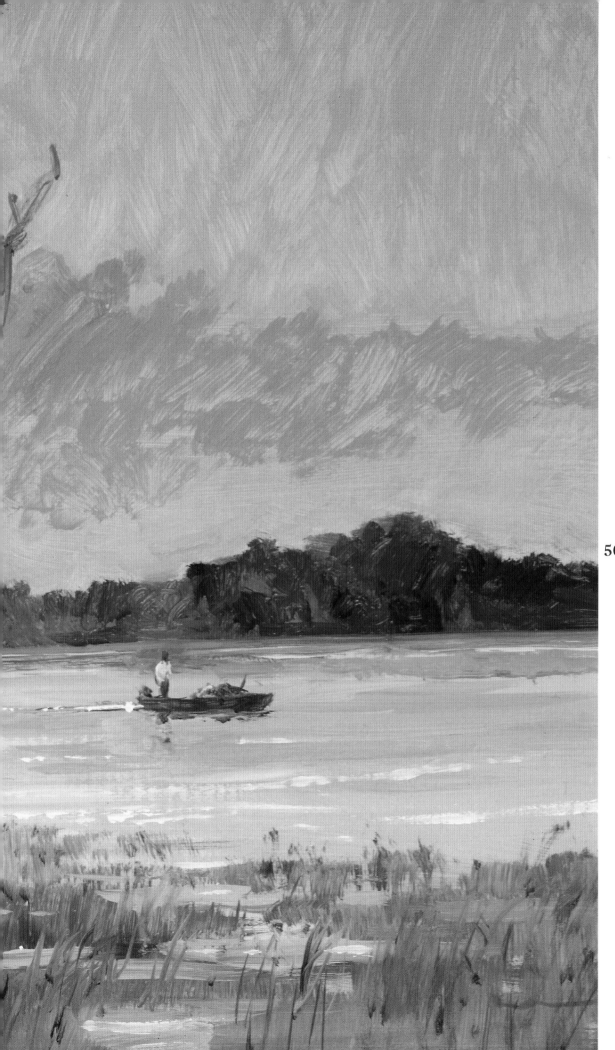

**50. On the Tidal Creek**

65

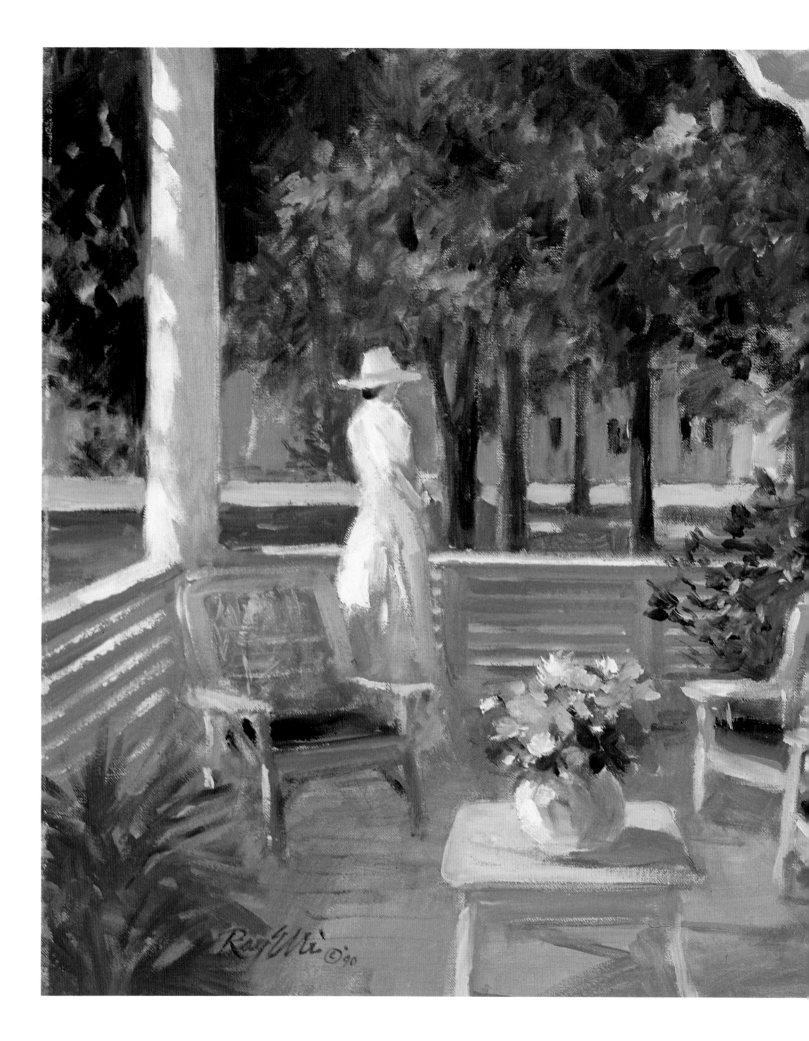

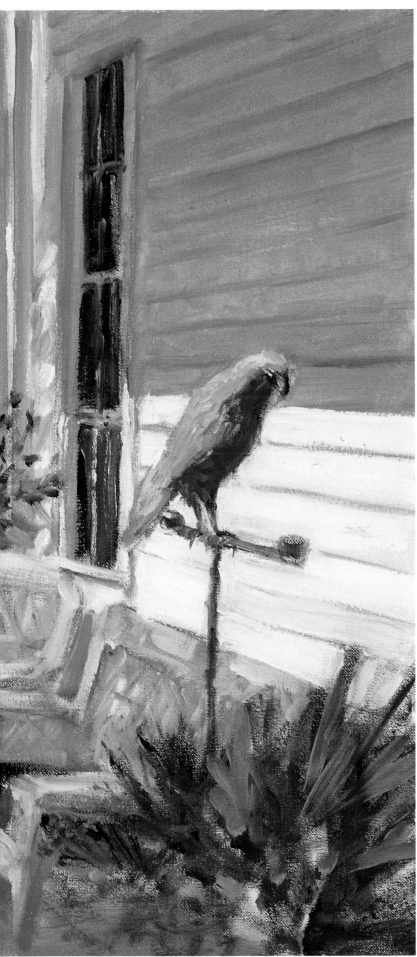

### 51. RAMA'S PORCH

*My first studio in Savannah was at Barnard and Harris Streets on Pulaski Square. A familiar sight to passers-by was my Yellow-Naped Amazon parrot Rama out on the side porch. In those days, he was rarely in his cage and would talk a streak to people walking beneath. It was known as 'Rama's Porch'.*

67

**52.** Near The Cathedral

**53.** River Street Sketch

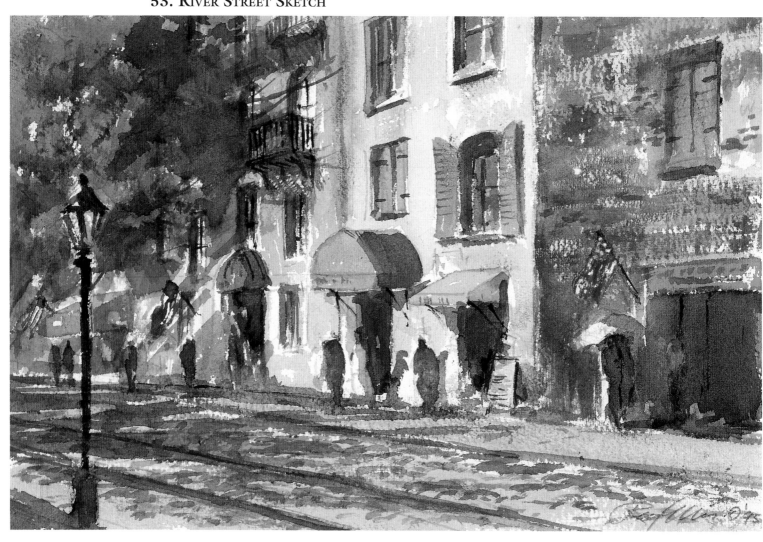

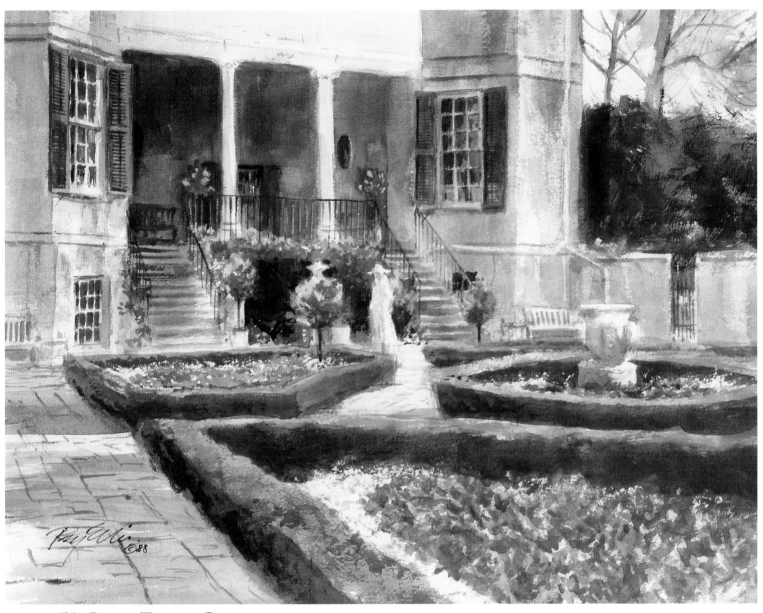

**54. OWENS-THOMAS GARDEN**

*I originally painted this garden for a book I did with Louisa Wood back in 1981. After she redesigned the garden I went back in 1988 and painted it from a different perspective.*

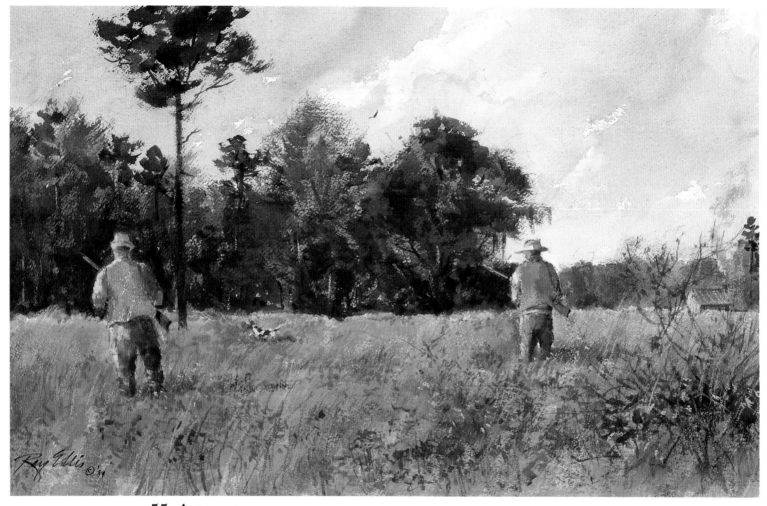

**55. A**NTICIPATION

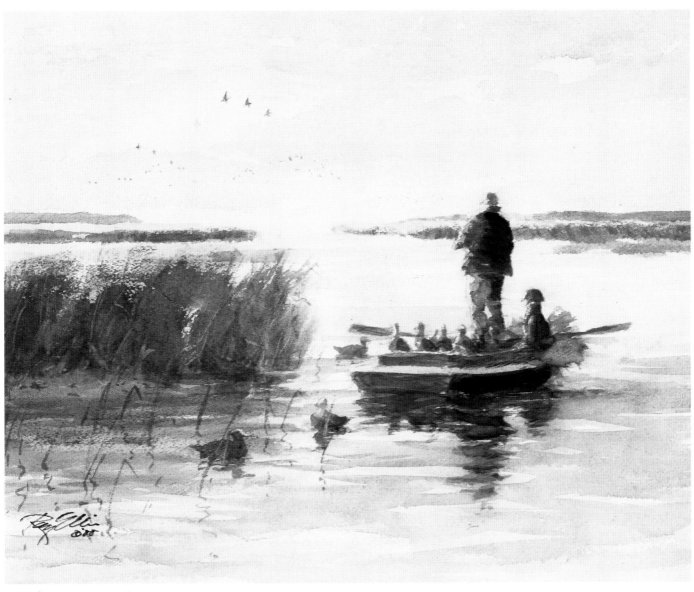

**56. START OF DAY**

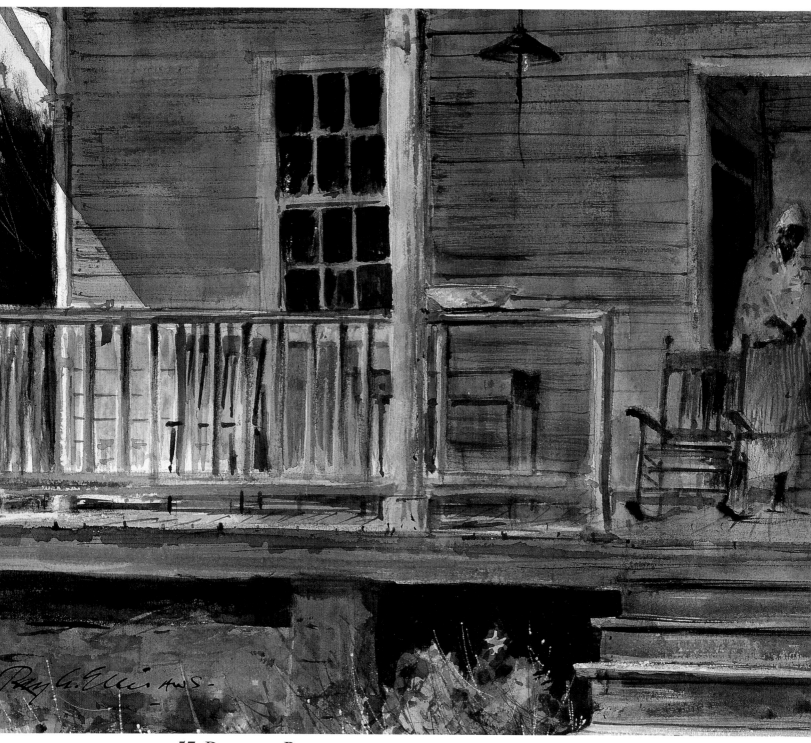

### 57. DAUFUSKIE PORCH
*Back in the 1970's, I made many trips by boat to Daufuskie, then an unspoiled island near Hilton Head. This was a very spontaneous watercolor of a typical old porch. The wash basin and rocking chair caught my eye.*

72

## 58. WAITING

*The patience of a hunting dog—here a yellow Labrador—is remarkable. Being some-what impatient myself, I wanted to capture it in paint.*

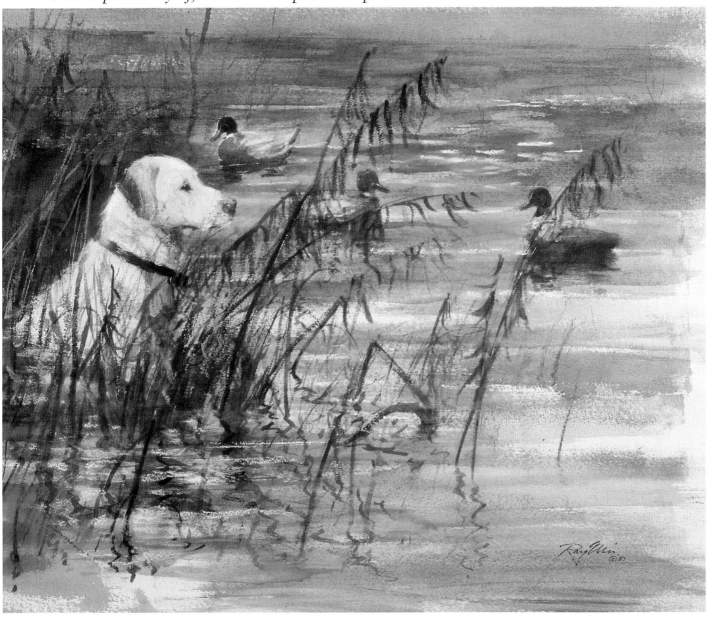

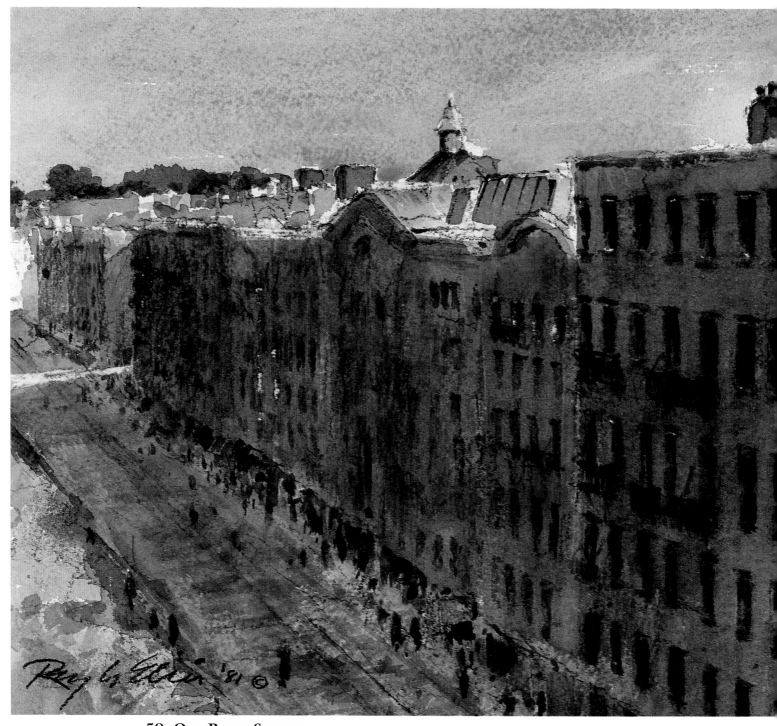

**59. OLD RIVER STREET**

*In late afternoon, the facades of buildings along River Street are in shadow, but the slanting sunlight hits the rooftops and shines between the structures, making a dramatic composition.*

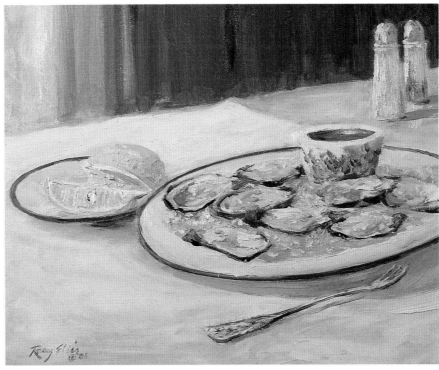

**60.** OYSTERS ON THE HALF SHELL

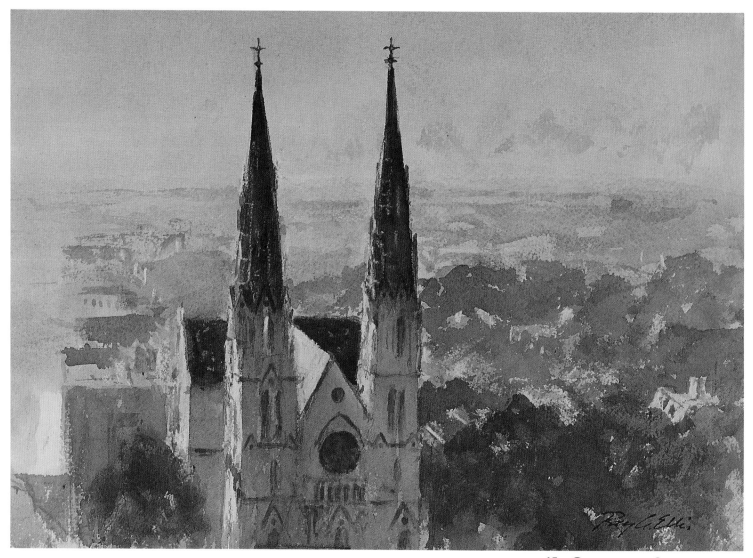

**61. Cathedral Spires**

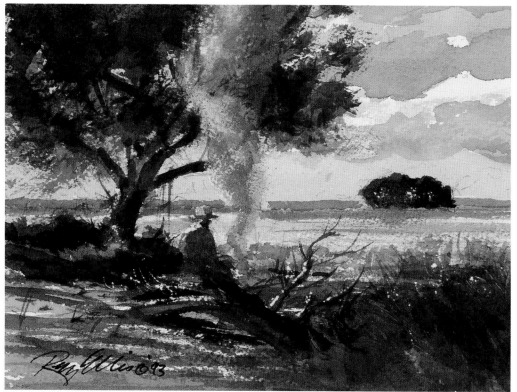

**62. Winter Marsh**

## 63. CITY MARKET AREA

*One of the attractions in Savannah is the newly-restored City Market area. Fine restaurants, art galleries, night spots, and boutiques abound in buildings which not so long ago were run-down and vacant.*

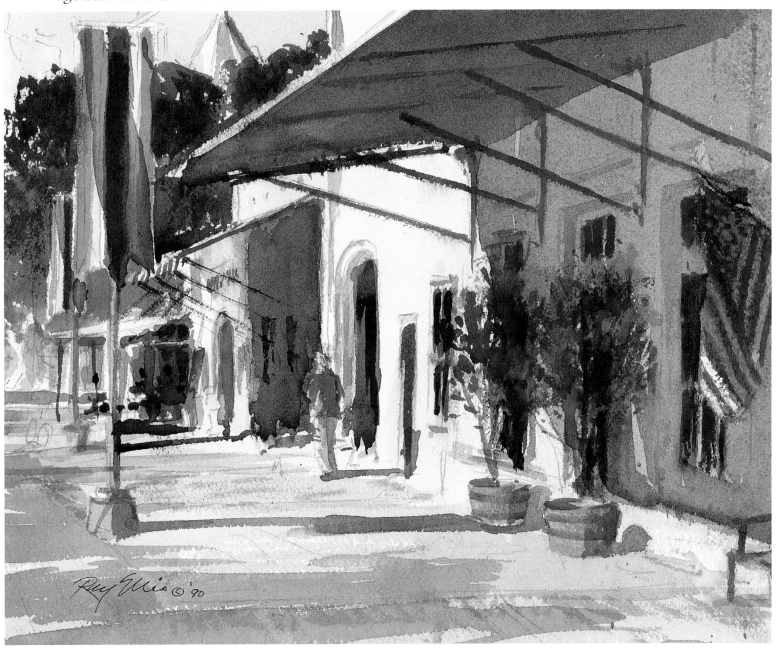

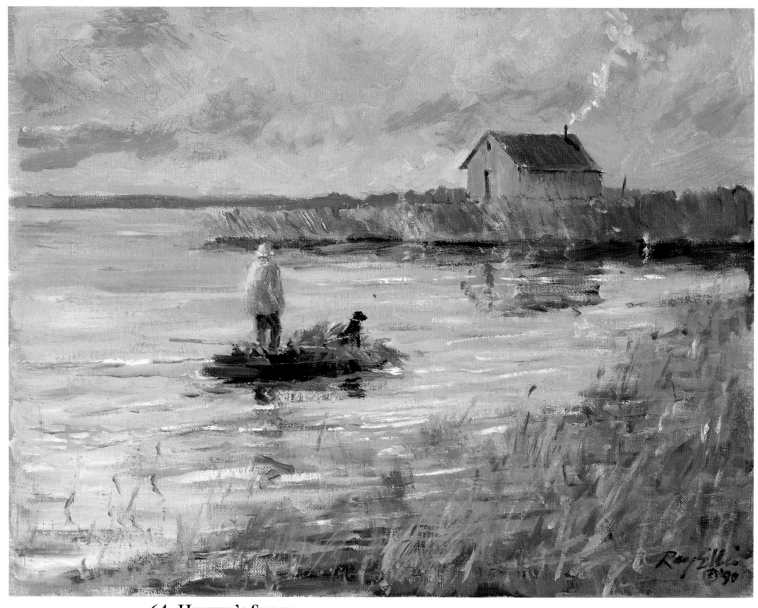

**64. HUNTER'S SHACK**

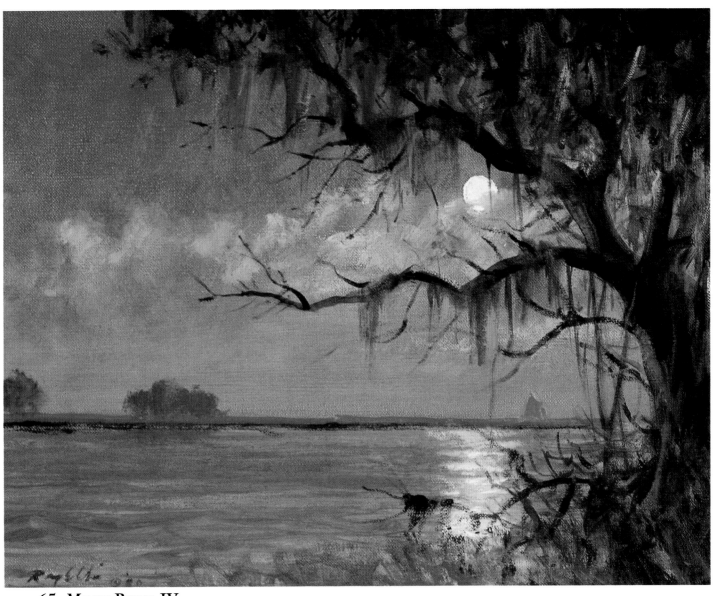

## 65. MOON RIVER IV

*This is one in a series of moonlight paintings inspired by Savannah's own Johnny Mercer. I can understand why this subject moved him to write such a beautiful song about it.*

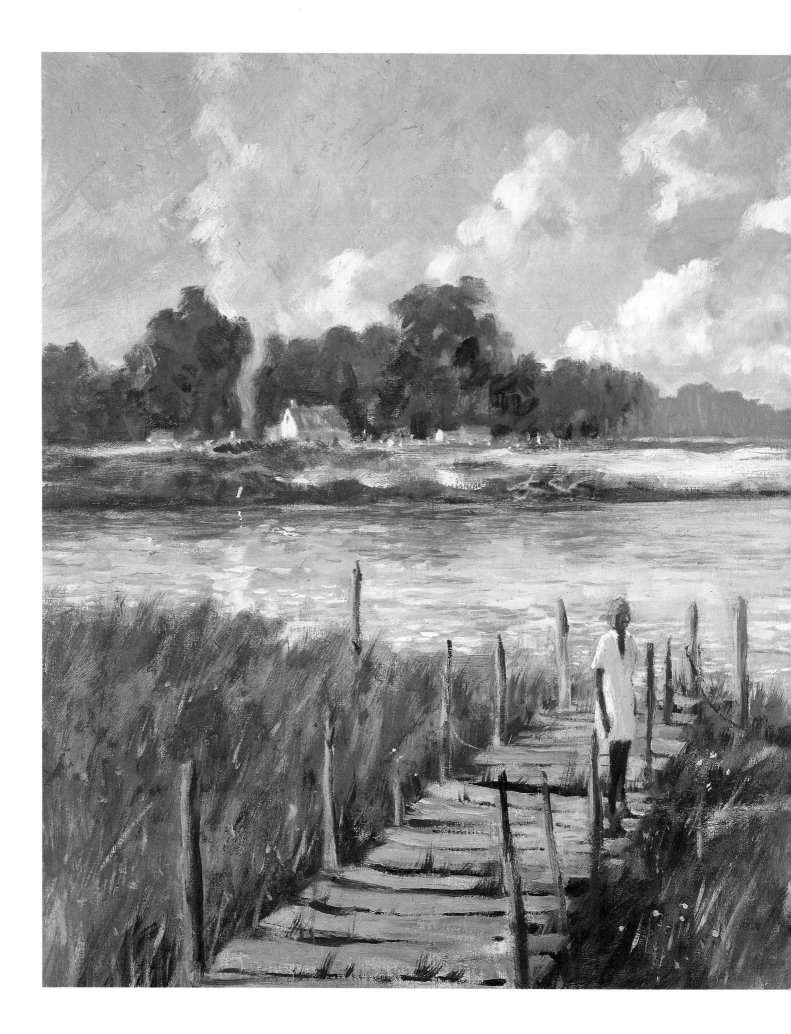

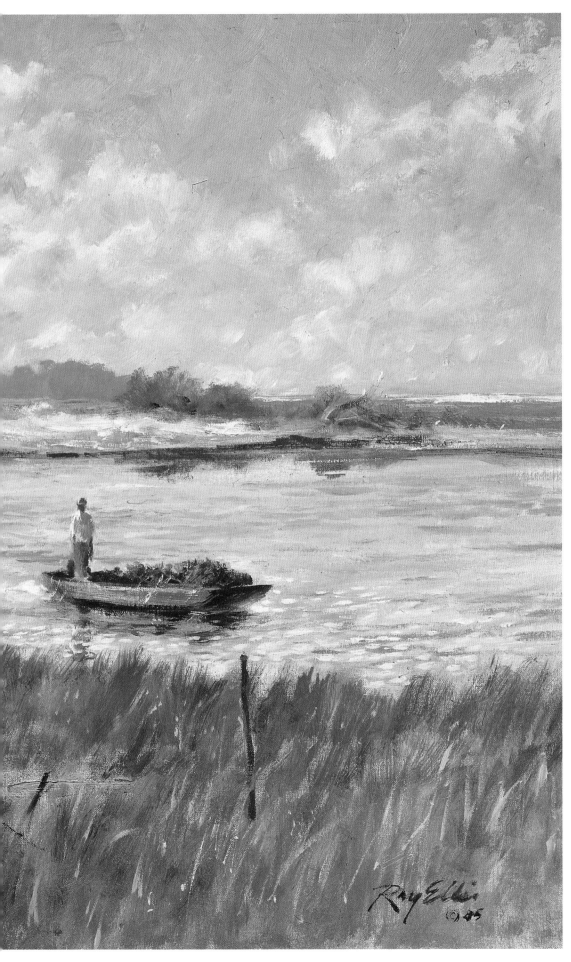

**66. LOWCOUNTRY DOCK**
*There are hundreds of old
weathered docks like this
along the waterways.
Many of them are used by
bateaux and larger boats
as their home base.*

NEXT SPREAD:

**67. ON THE SHALLOWS**

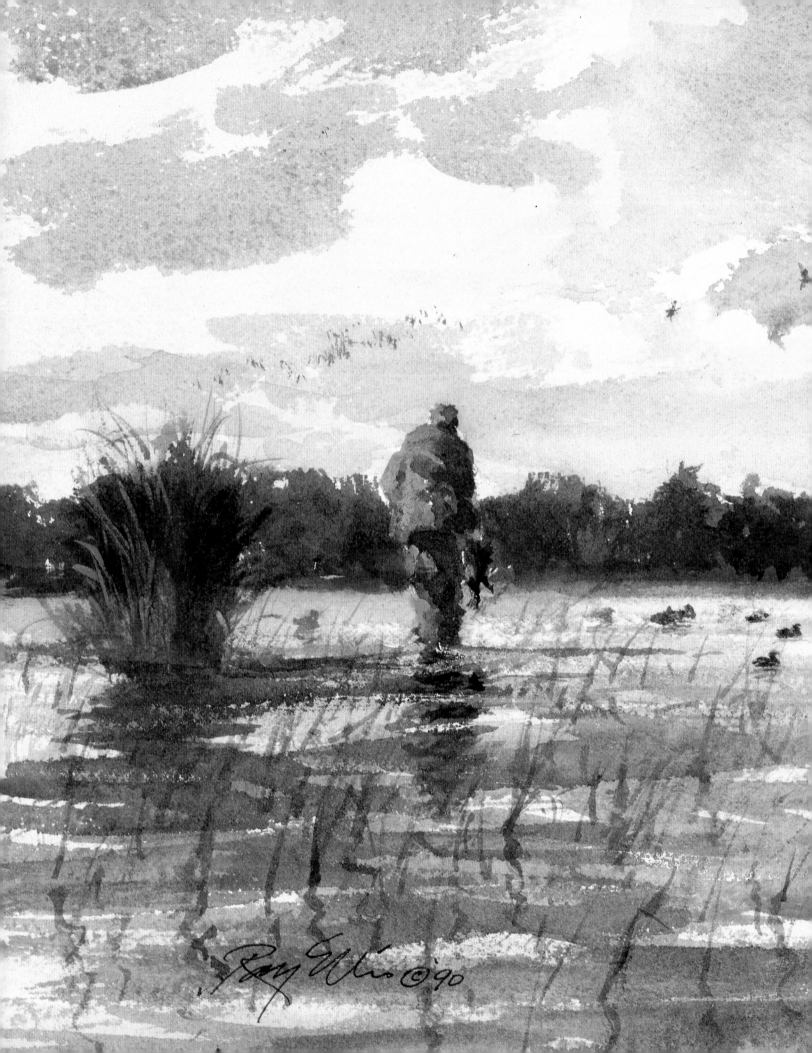

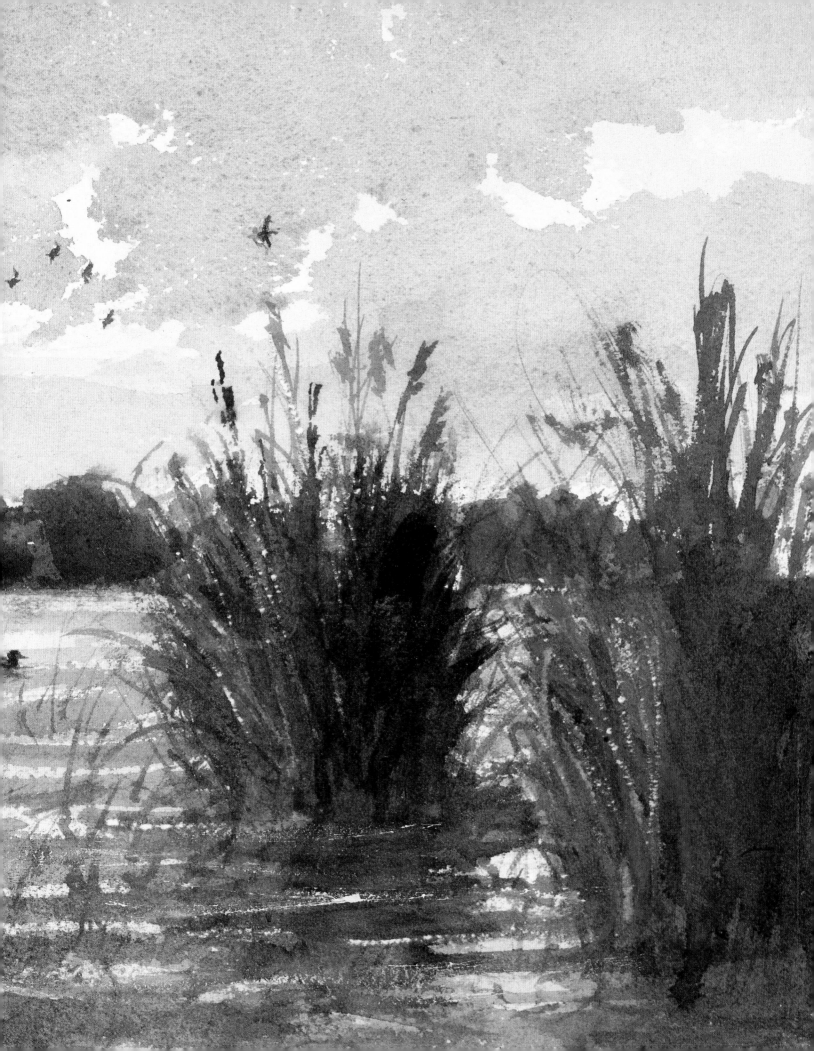

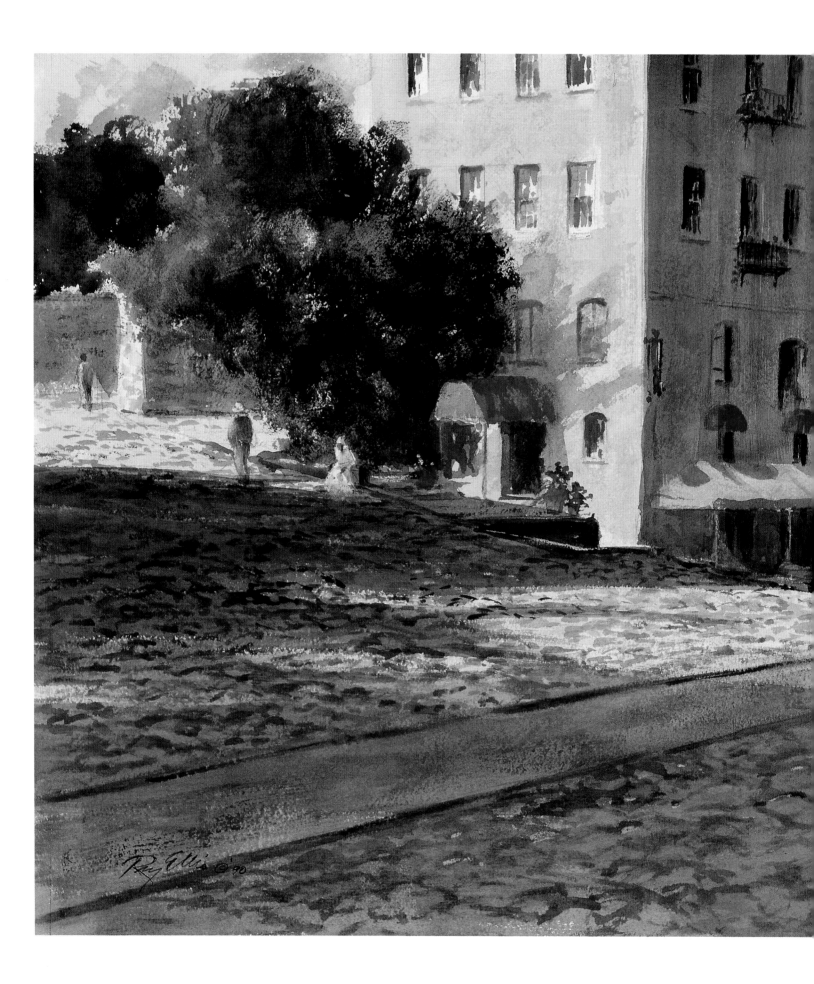

**68. MONDAY MORNING—RIVER STREET**
*Shadows wash across the cobblestones and rail-
road tracks by the old Boar's Head Tavern on
a quiet Monday. There is a wonderful light at
this time of day.*

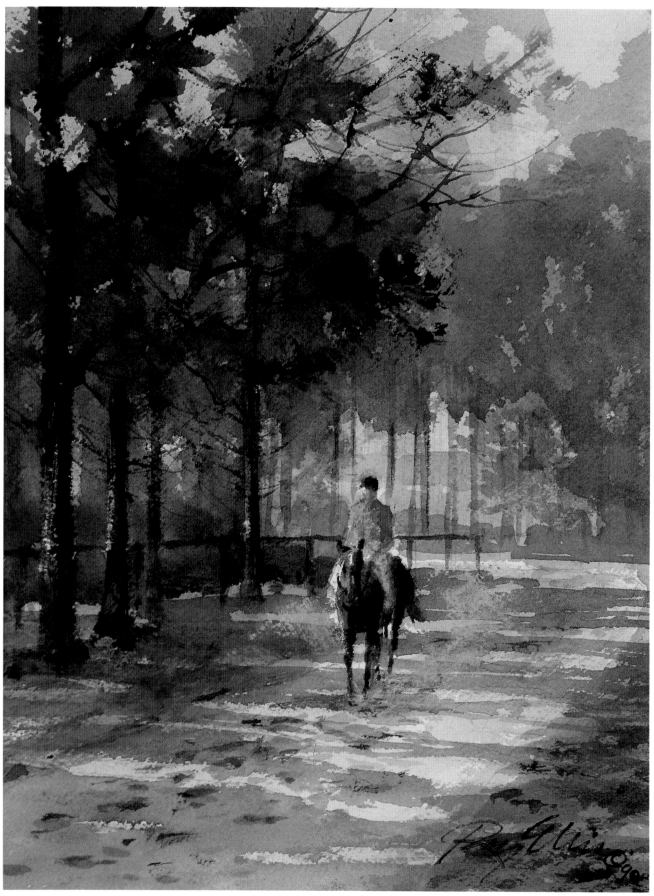

**69. BACK FROM THE HACK**

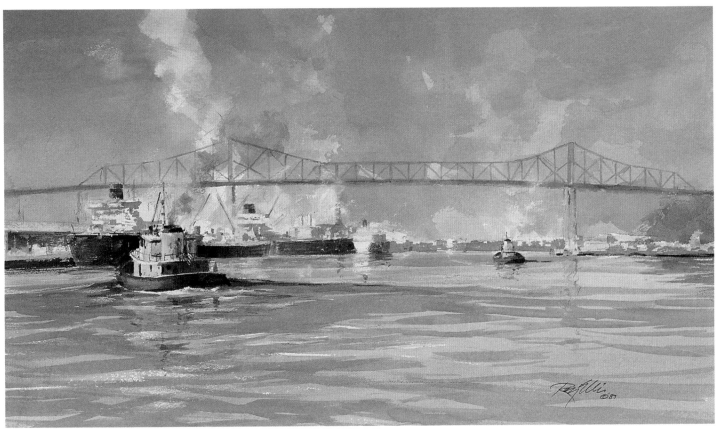

## 70. OLD TALMADGE BRIDGE
*Even before the new Savannah River bridge was built, the port of Savannah ranked among the top three busiest ports on the East Coast. While the river is comparatively narrow, it bustles with activity.*

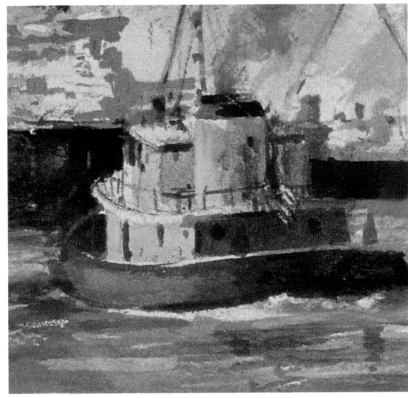

DETAIL

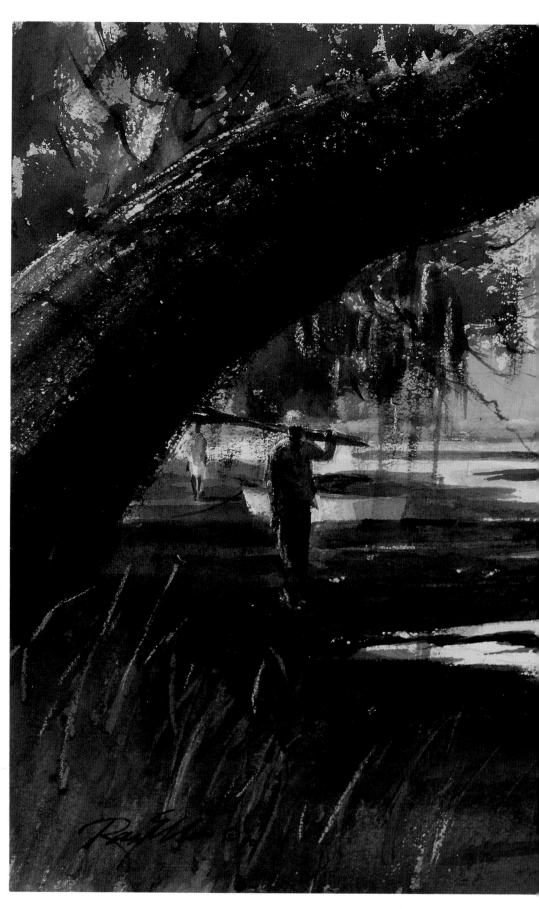

### 71. TIDAL CREEK

*One of the fascinating things about low tide is the wonderful abstract forms and patterns that appear in the tidal pools. Here a boatman returns home, carrying his oars on his shoulder, while egrets and other fowl search for food in the shallows.*

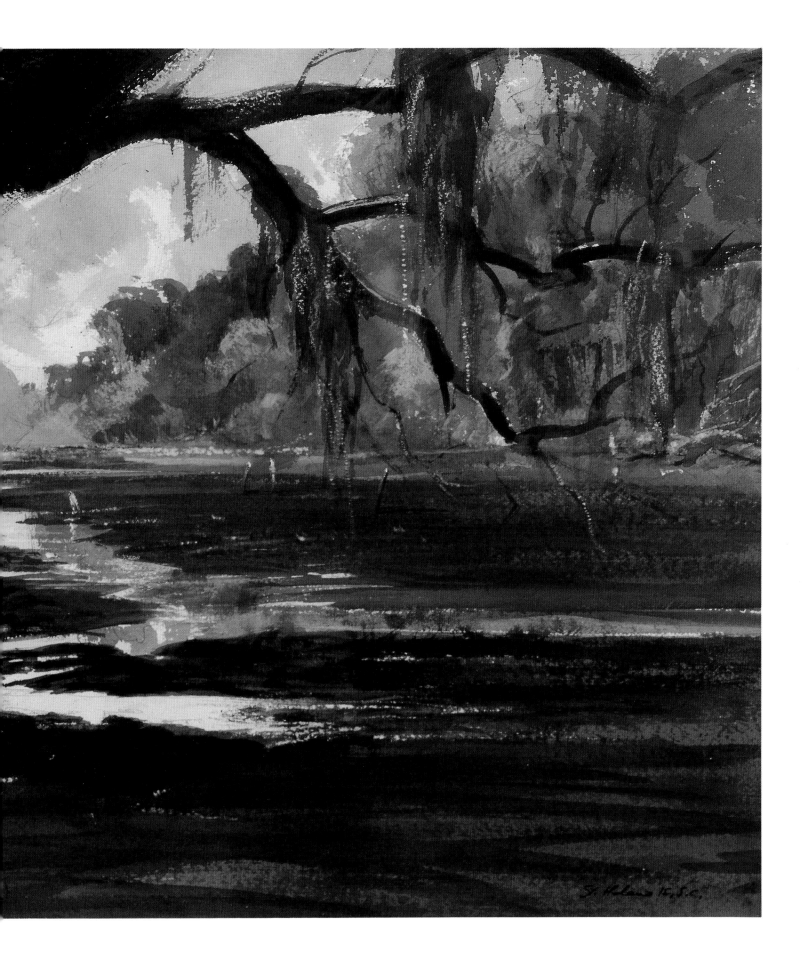

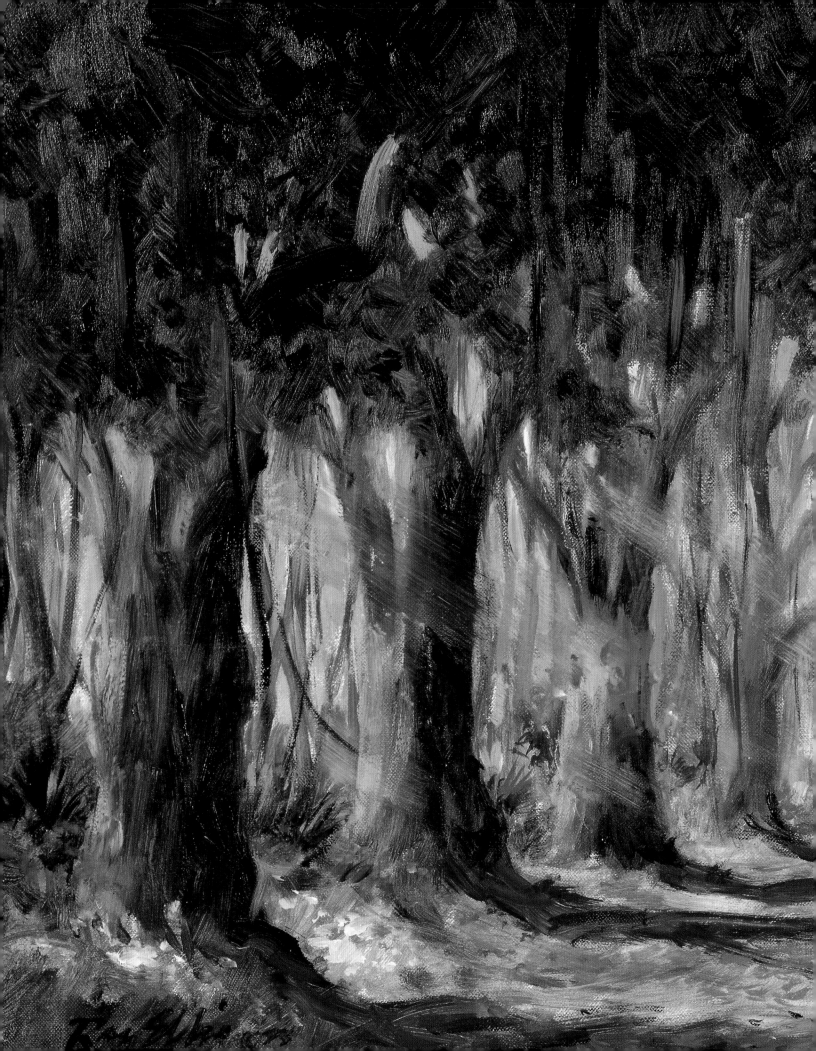

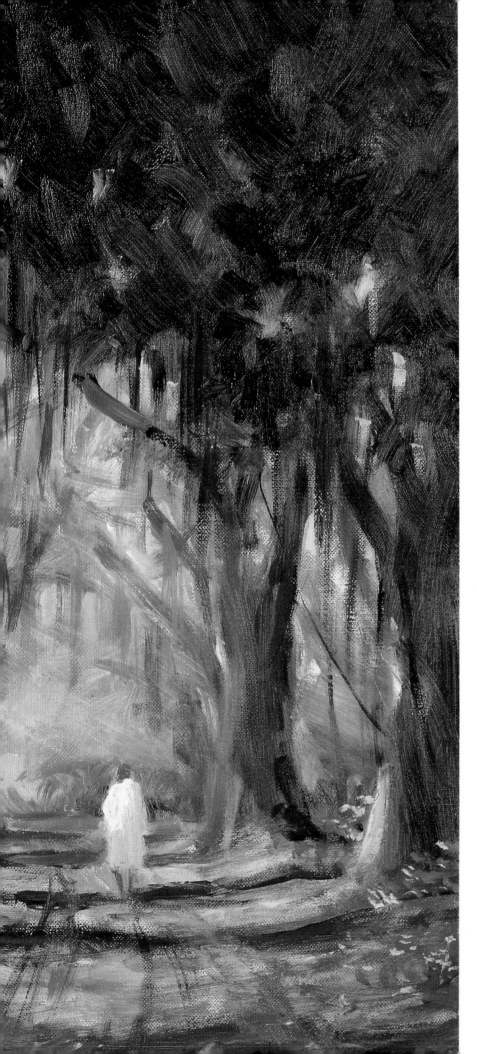

**72. Ossabaw**

Next Spread:

**73. Old City Market**
*I arrived in Savannah a few years too
late to see one of the city's treasured
landmarks, the Old City Market. Ironi-
cally, it was located on 'Ellis' Square
(no relation!). I found some old tintypes
and painted the market as I imagined
it had looked in its heyday.*

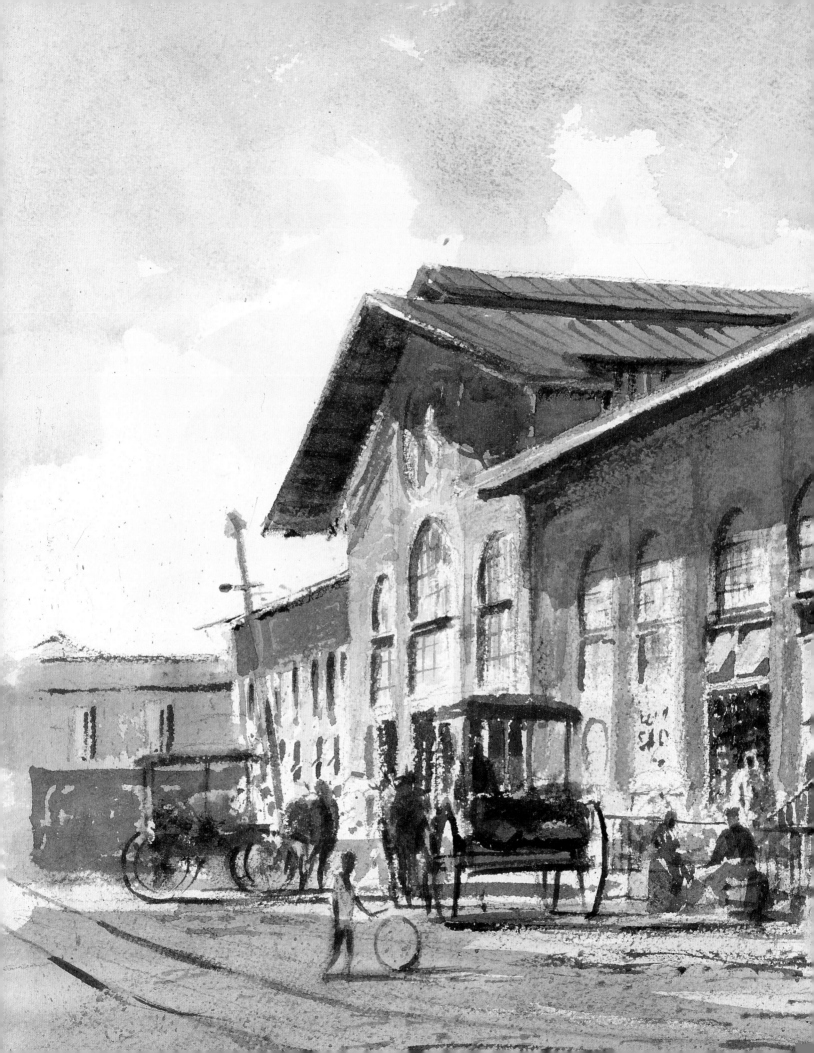

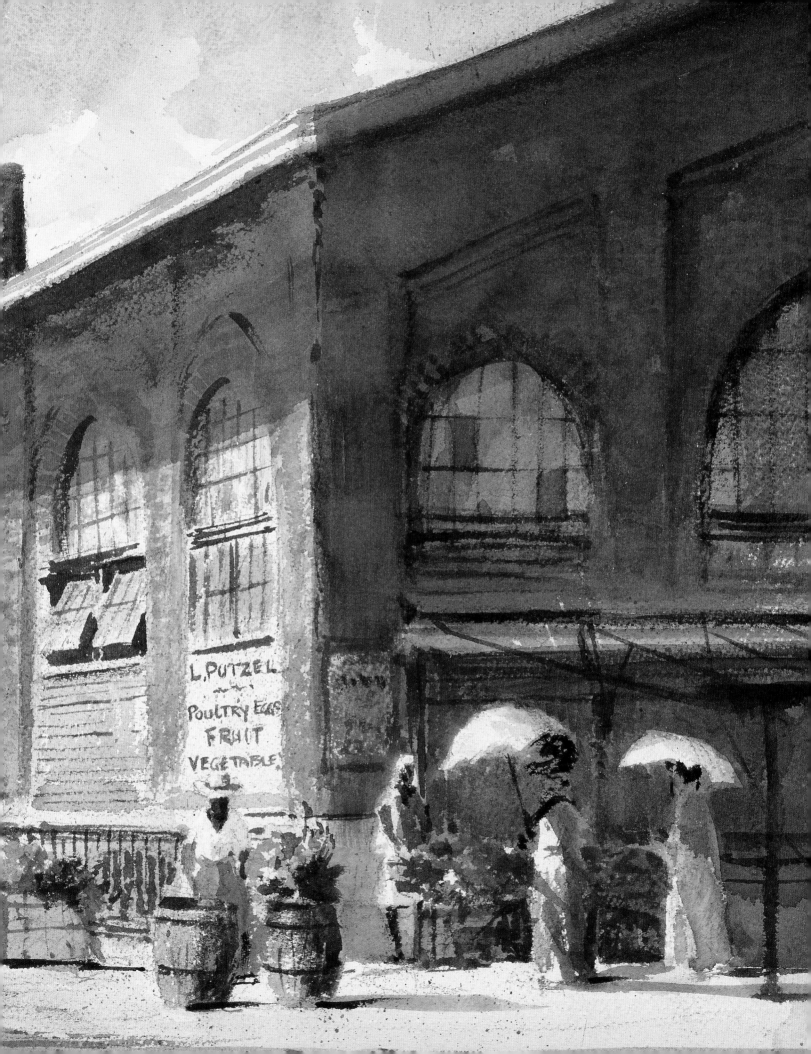

## 74. WATER LILIES

*Creeks and ponds are sometimes covered with the most beautiful pink and white water lilies. Duck hunters and fishermen pole through them looking for a secluded spot.*

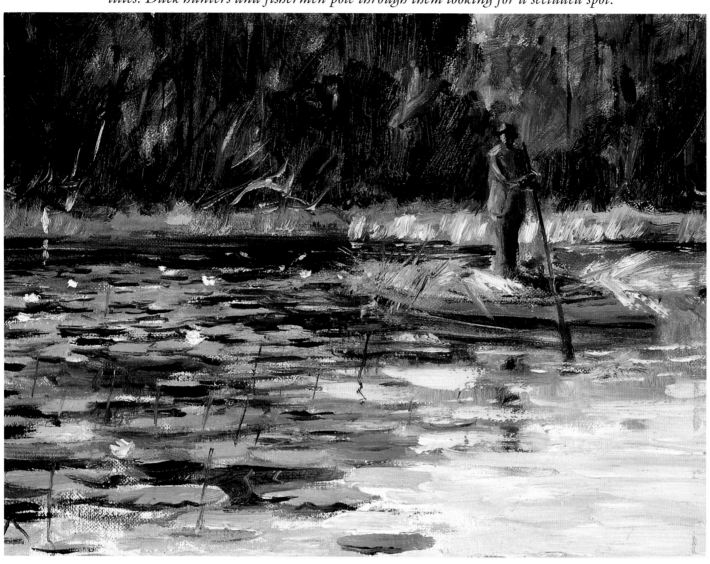

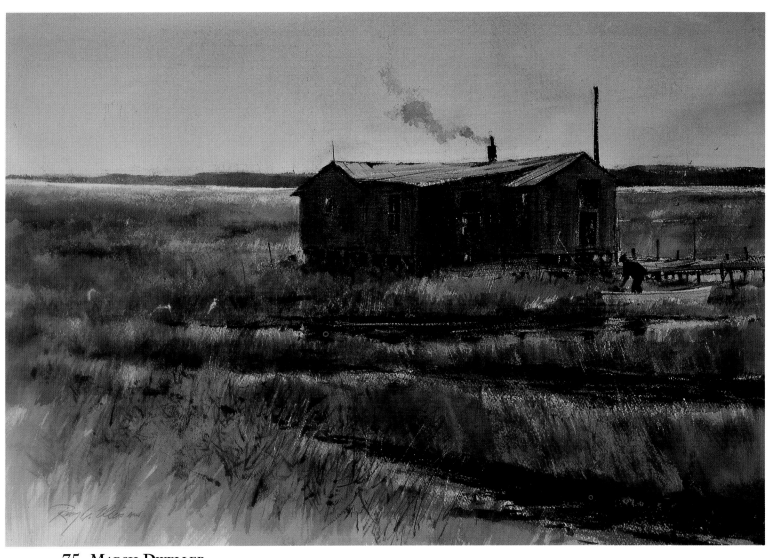

## 75. MARSH DWELLER

*On one of my many trips on the Inland Waterway, this weathered fisherman's shack seemed to symbolize man's eternal capacity of survival. The many angles of the building silhouetted and reflected in the wet marsh made a dramatic subject.*

**DETAIL**

**76. OAK TREE SWING**
*Most natives of the Lowcountry recall from their child-hood a tire swinging from an old oak limb—a source of simple pleasure worth recording.*

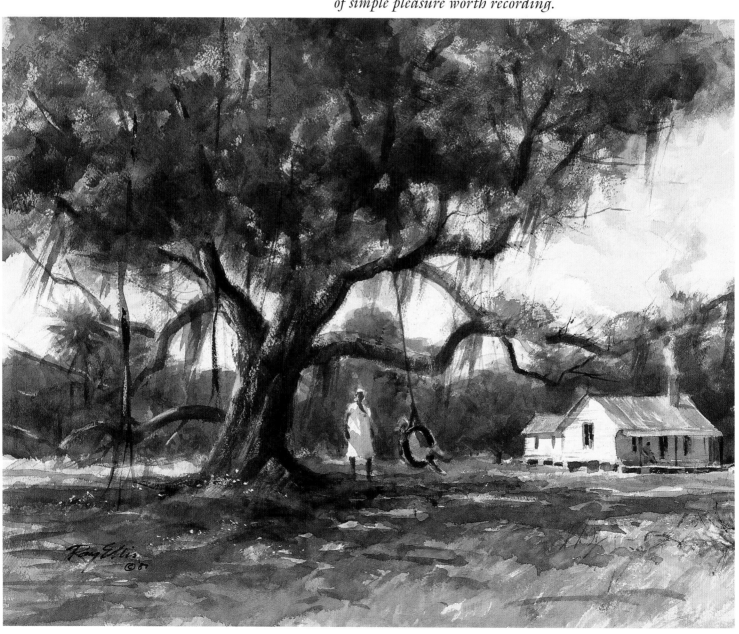

## 77. FALL MARSH

*They say in the Lowcountry that the marshes can change color and mood every few minutes. This is most evident in fall when the colors change from green to brown and even to shades of lavender.*

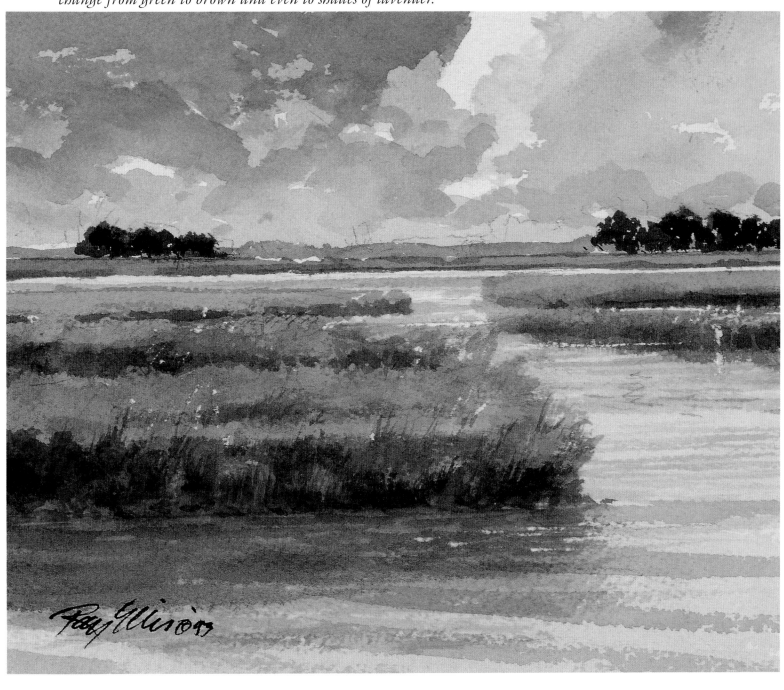

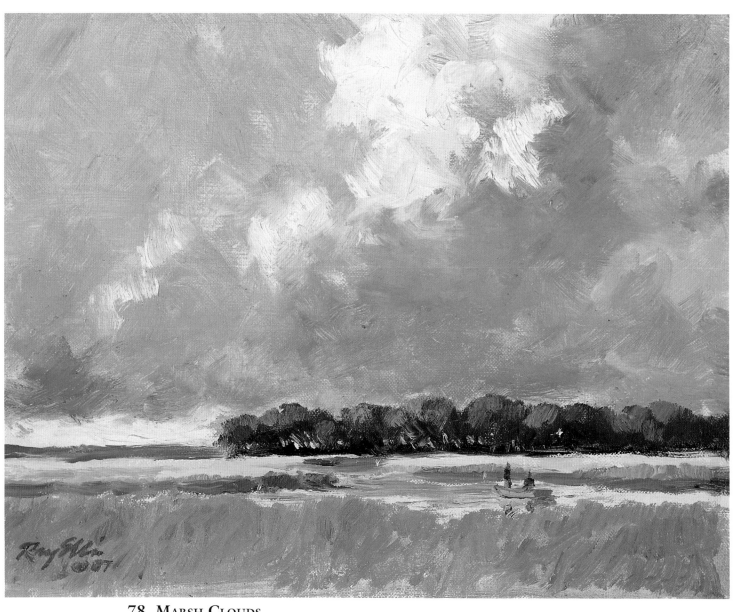

**78. MARSH CLOUDS**

*Of all the places I have painted, perhaps with the exception of the Western plains, no other place has more spectacular clouds than the Lowcountry.*

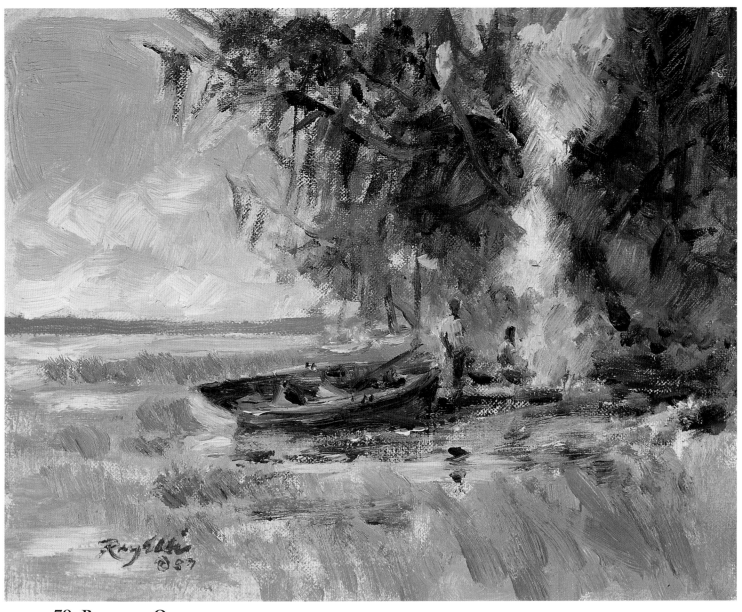

**79. ROASTING OYSTERS**

*This subject is among my favorites. Ever since my first trip to Daufuskie Island, I have been fascinated with oystermen by the fire passing the time of day.*

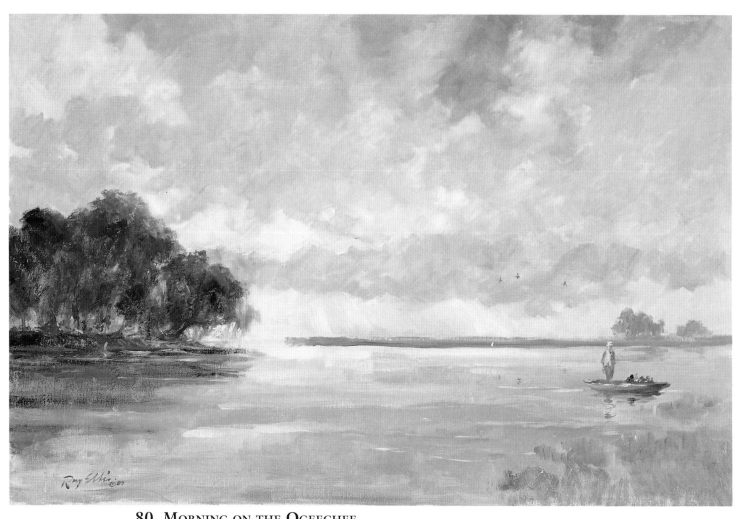

**80. MORNING ON THE OGEECHEE**
*This river has been a favorite of sportsmen, fishermen, and hunters for a very long time.*
*Here a duck hunter sets out his decoys.*

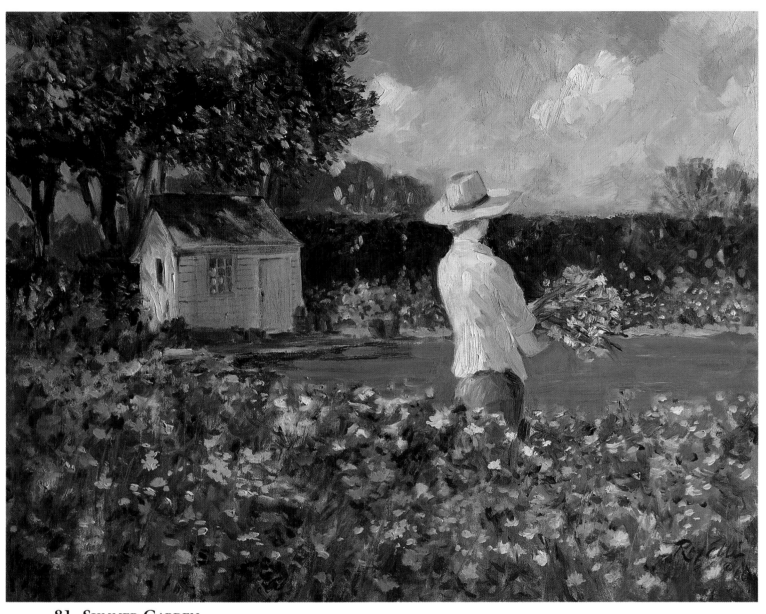

**81. SUMMER GARDEN**

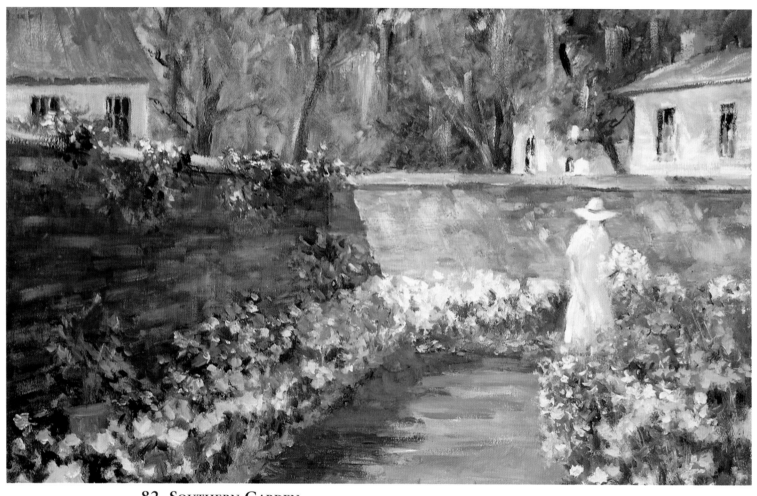

### 82. SOUTHERN GARDEN
*Walled gardens are not exclusive to Savannah, but the city certainly has its share. Whether brick or masonry, the walls make a perfect backdrop for painting flowers and shrubs.*

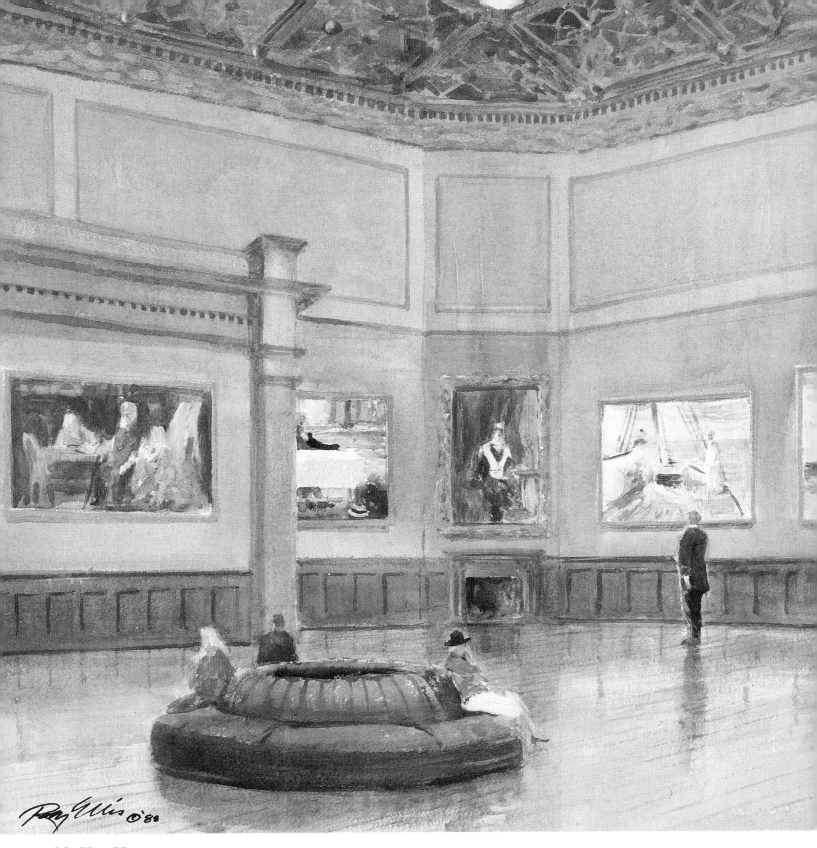

**83. THE VIEWERS**

*Telfair Academy, Savannah's prestigious art museum, has always meant a great deal to me. I never tire of looking at its wonderful collection of paintings, particularly the ones by American Impressionists. This watercolor depicts the restored Rotunda Room.*

103

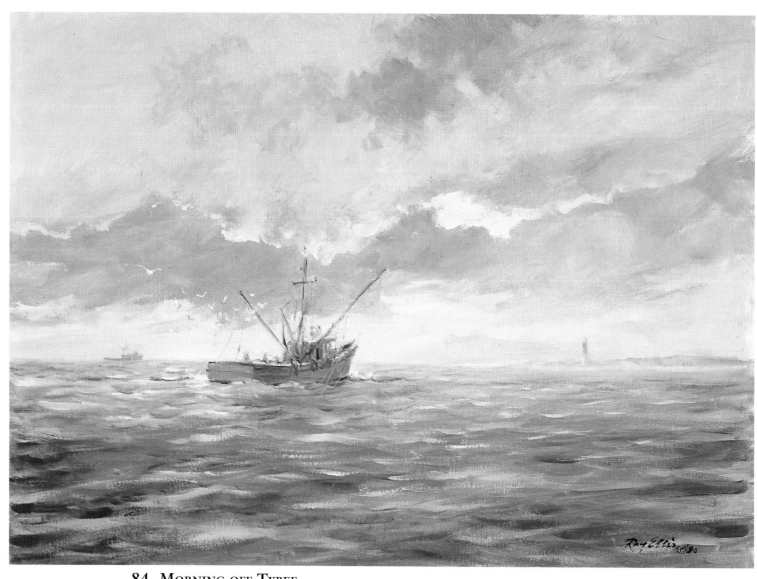

**84. MORNING OFF TYBEE**

*At least one shrimpboat can usually be seen off Tybee Island, particularly early in the morning. Here I depicted a "shrimper" in the foreground with Tybee Light just visible in the distance and one of those spectacular sunrises the island is famous for.*

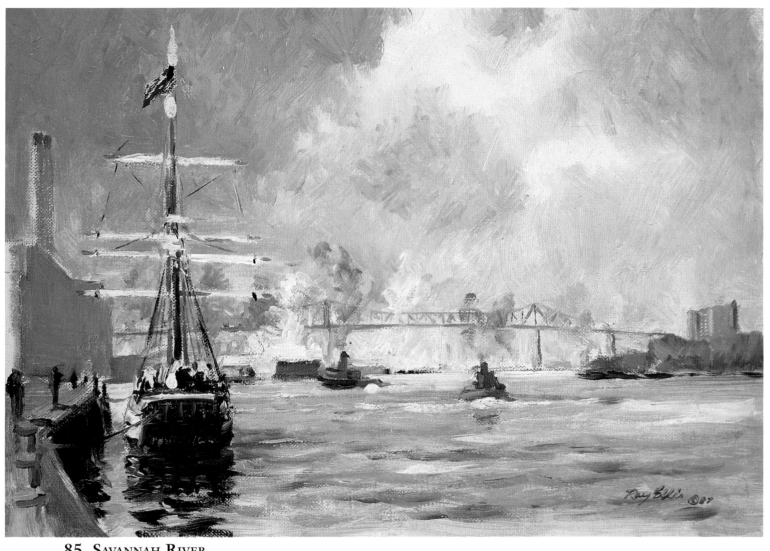

**85. Savannah River**

*The sailing ship 'Barba Negra' has been a great addition to the waterfront. This scene reminded me of some of Boudin's paintings of the Seine. With much of the interest taking place on the extreme left, it made an unusual composition.*

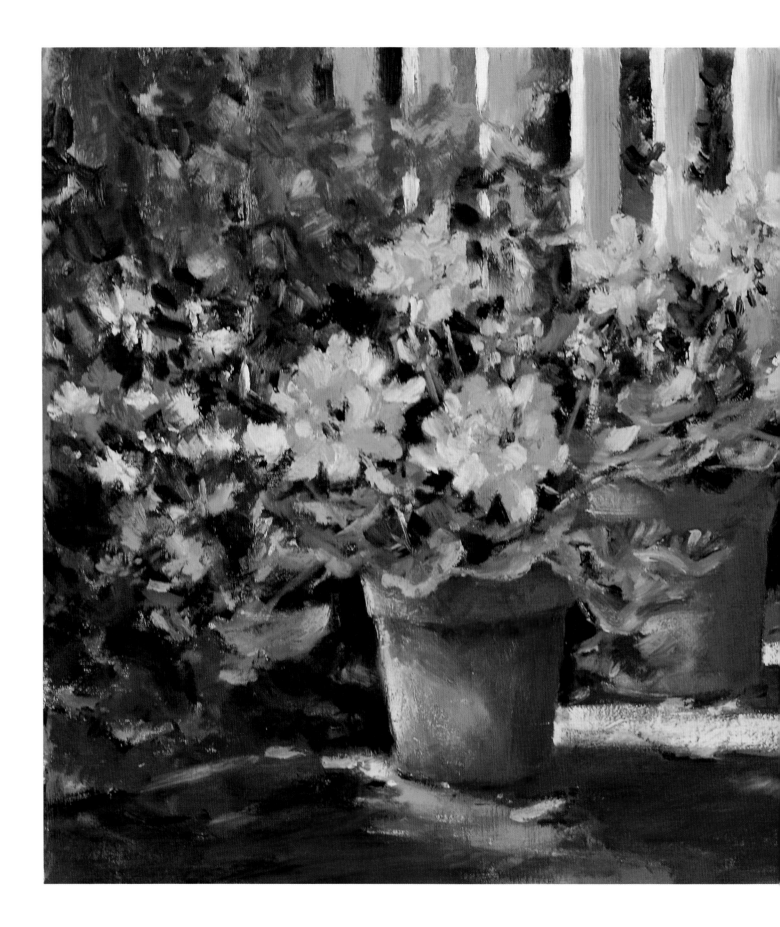

106

**Next Spread:**

**87. Dusk on the Sound**
*Nearly every time of day or night some type of boat can be seen moving along Calibogue Sound. Since my studio in those days was nearby, it became the subject of many of my paintings in the '70's and early '80's.*

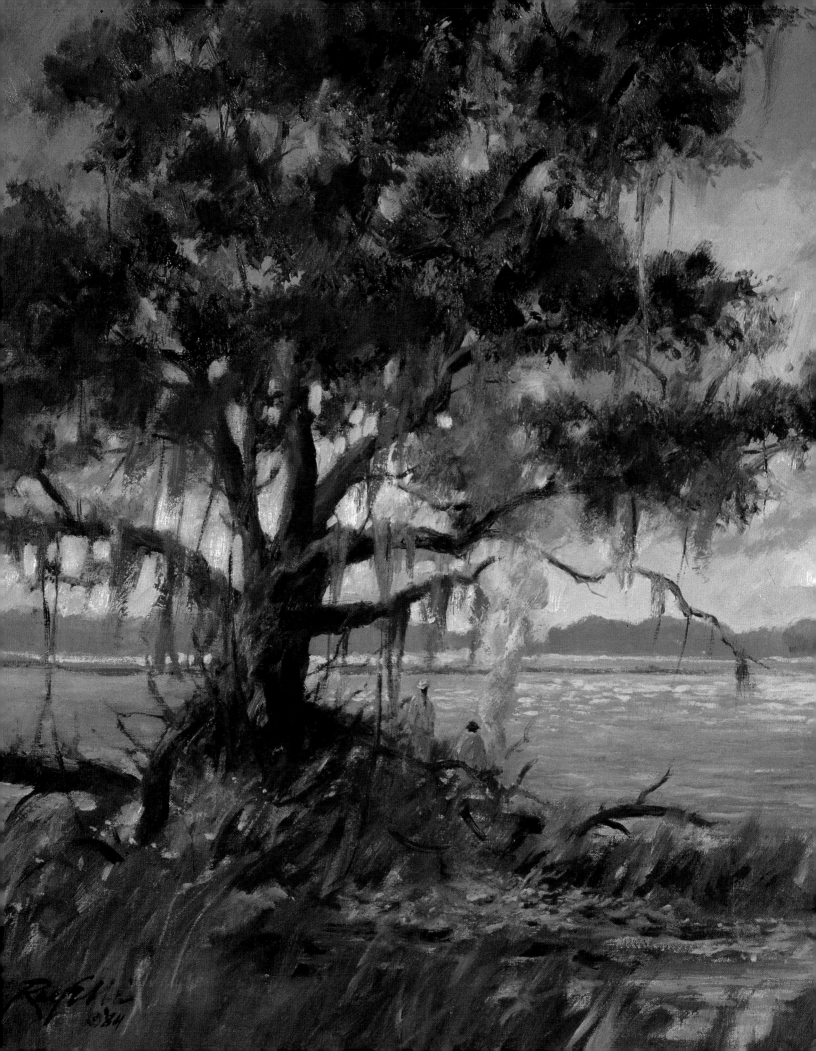

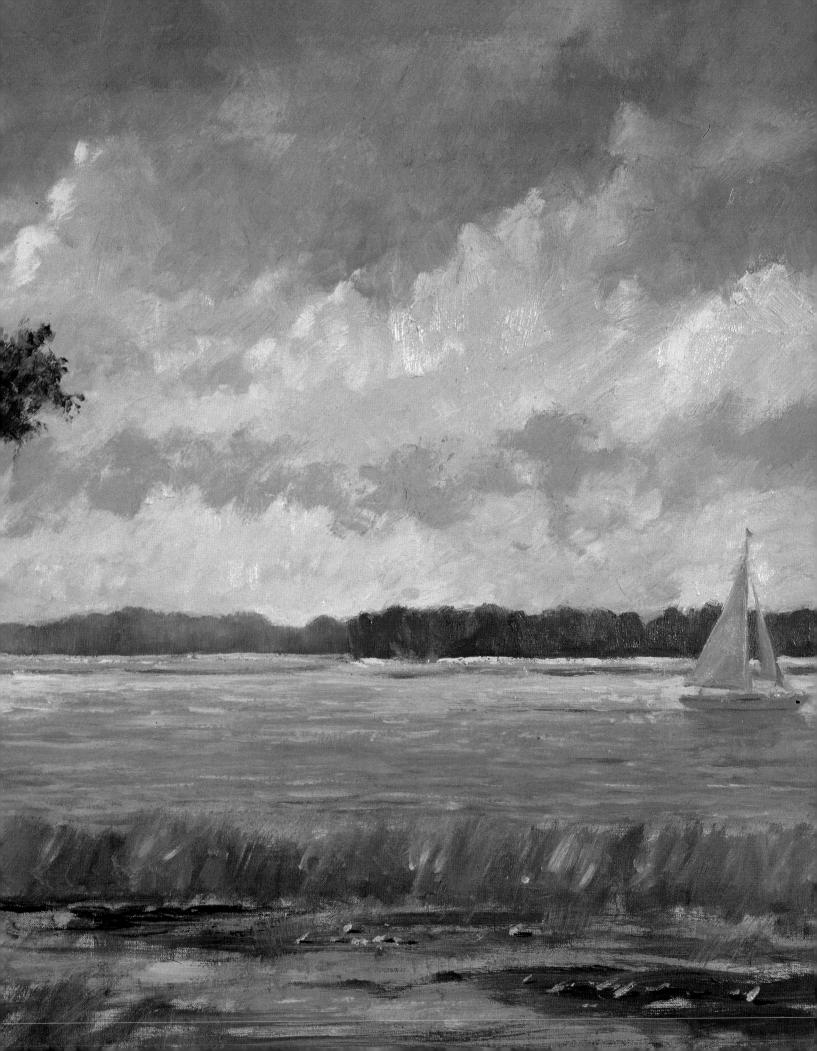

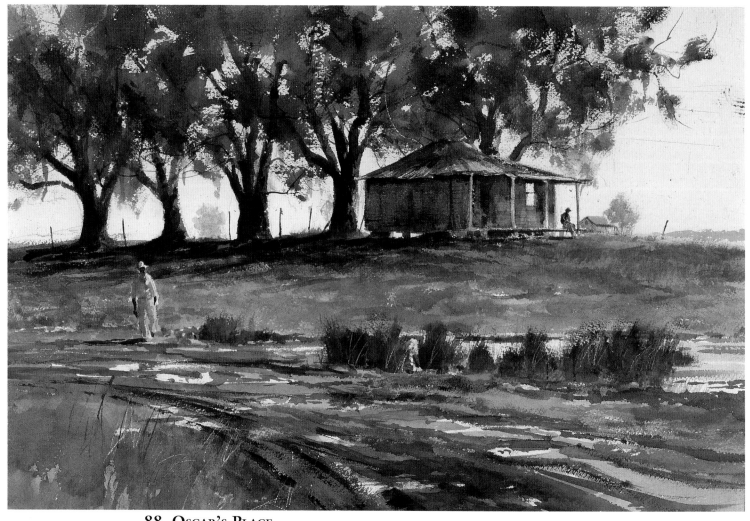

### 88. OSCAR'S PLACE

*Shortly after moving to Savannah, I was invited to visit and paint on an old rice plantation just across the Savannah River bridge in South Carolina. On a hummock under live oaks stood the caretaker Oscar's cabin. The curving, muddy road with puddles formed an ideal foreground.*

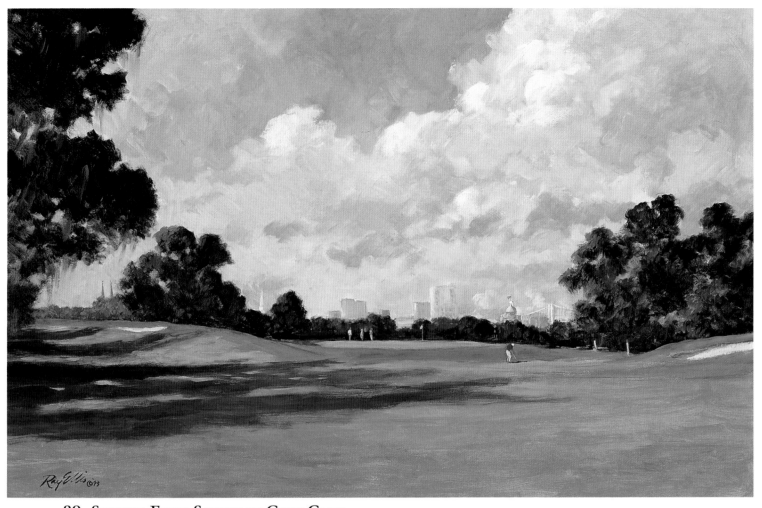

**89.** Skyline From Savannah Golf Club

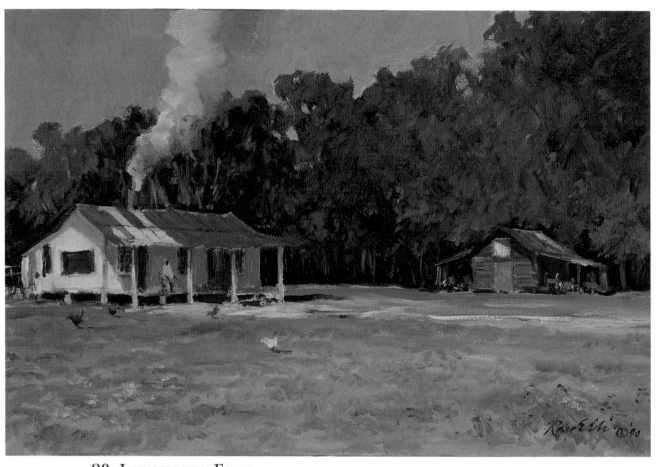

**90. LOWCOUNTRY FARM**

*Go down almost any road in the rural Lowcountry, and you will find subjects like this—full of nostalgia and atmosphere. The appeal for me, I suppose, is wanting to capture an era that is slowly but surely vanishing.*

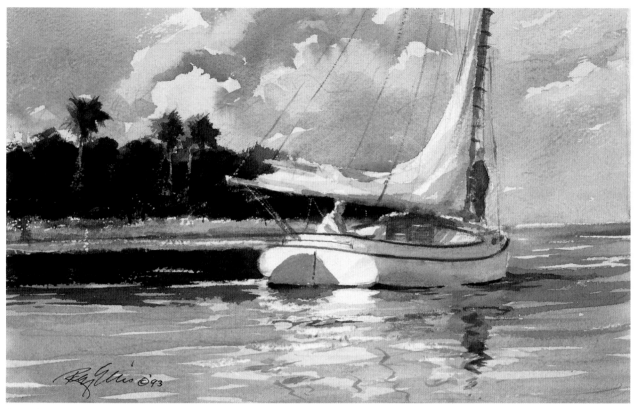

**91. SOUTHERN CATBOAT**
*As the proud owner of a catboat on Martha's Vineyard, I was always pleased when I saw an occasional one in the Lowcountry. They are a wonderful sight plodding sturdily along the Waterway.*

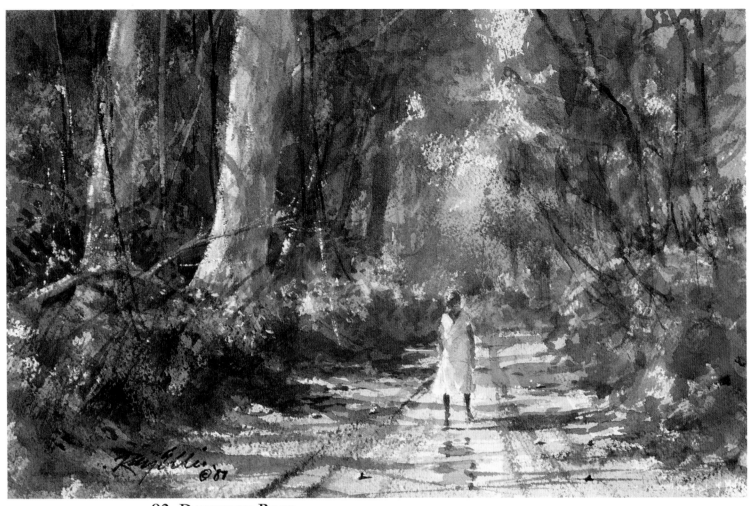

**92.** DAUFUSKIE ROAD

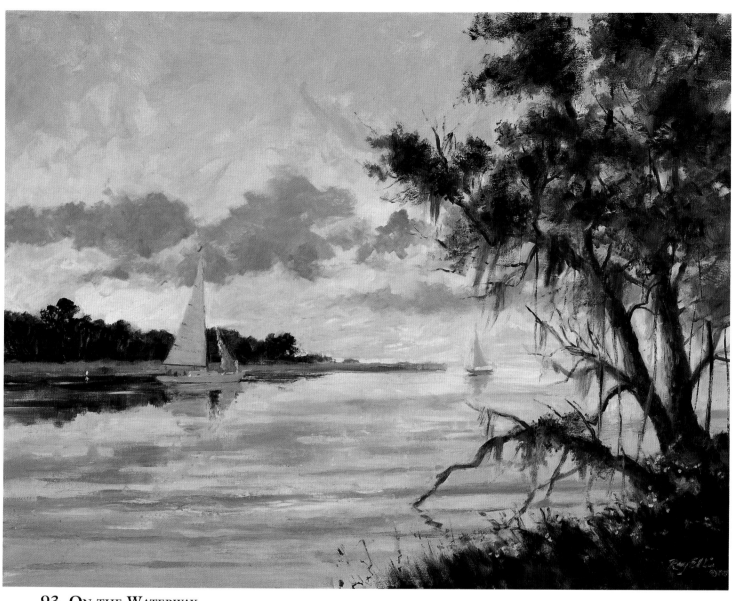

**93. On the Waterway**

*Sunrises in the Lowcountry can be just as spectacular as sunsets. Here orange and lavender hues are reflected in the water as a sloop heads south.*

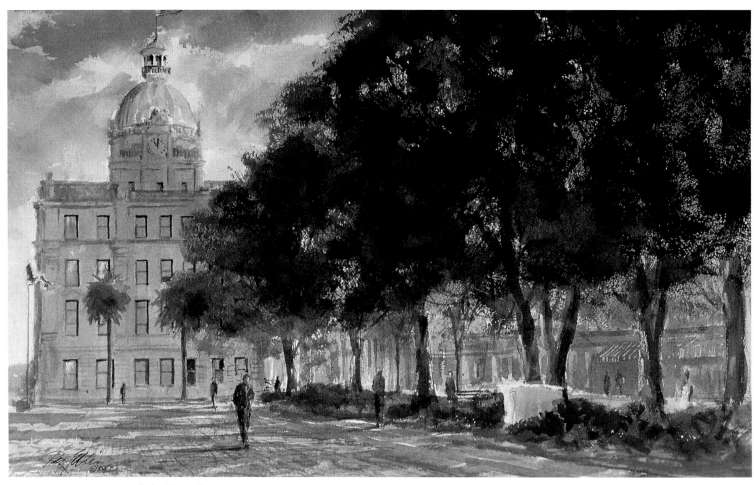

## 94. BAY STREET

*Bay Street, just south of Factors' Walk in Savannah, is a favorite promenade. The area has some of the oldest and most beautiful live oaks in the city. City Hall's dome was changed from green to gold just before I painted this watercolor.*

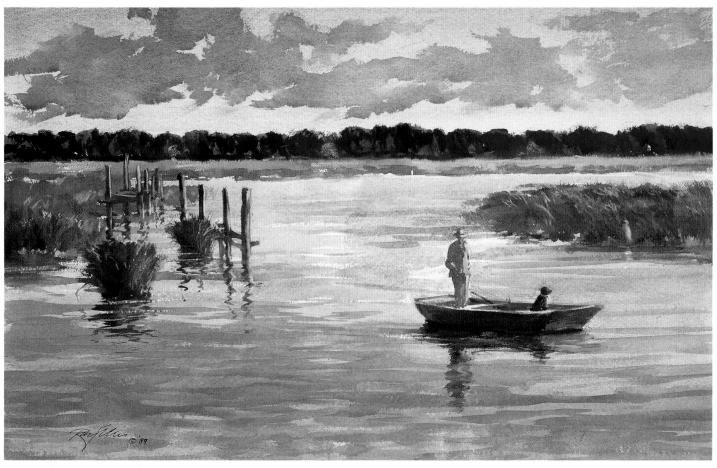

**95. Drifting Along the Marsh**

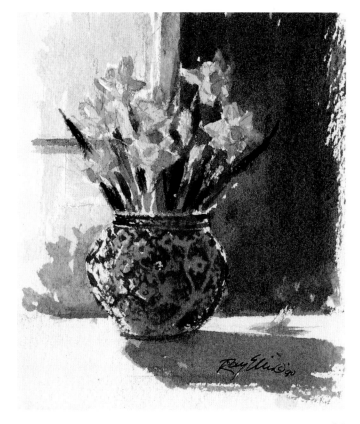

**96. Bowl of Daffodils**

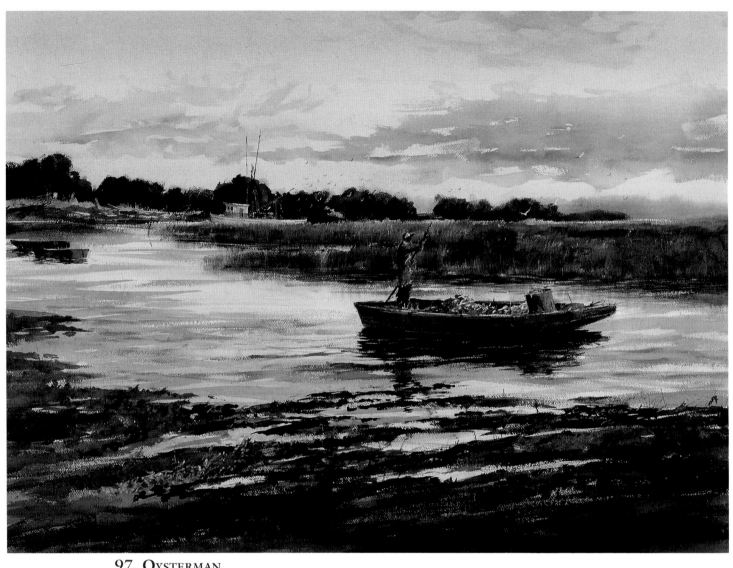

### 97. Oysterman

*The waters between Beaufort and Bluffton abound with oystermen and shrimpers. Ever since I arrived in the Lowcountry, they have been my favorite subjects.*

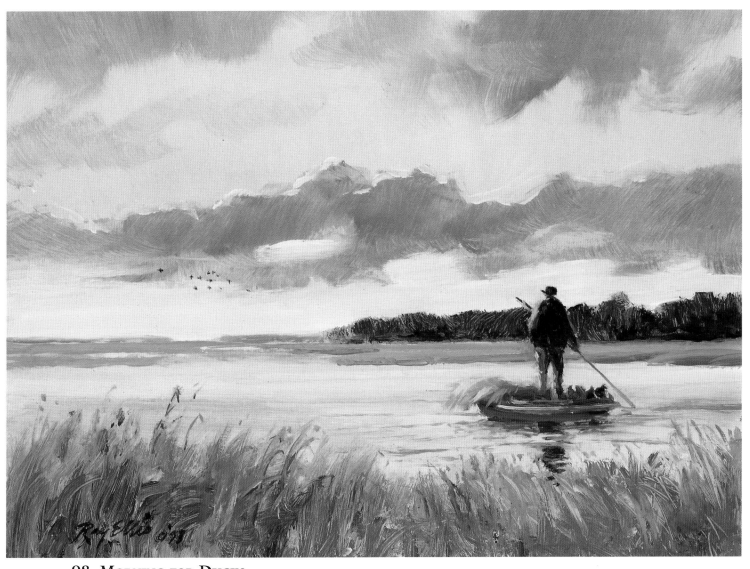

**98. Morning for Ducks**

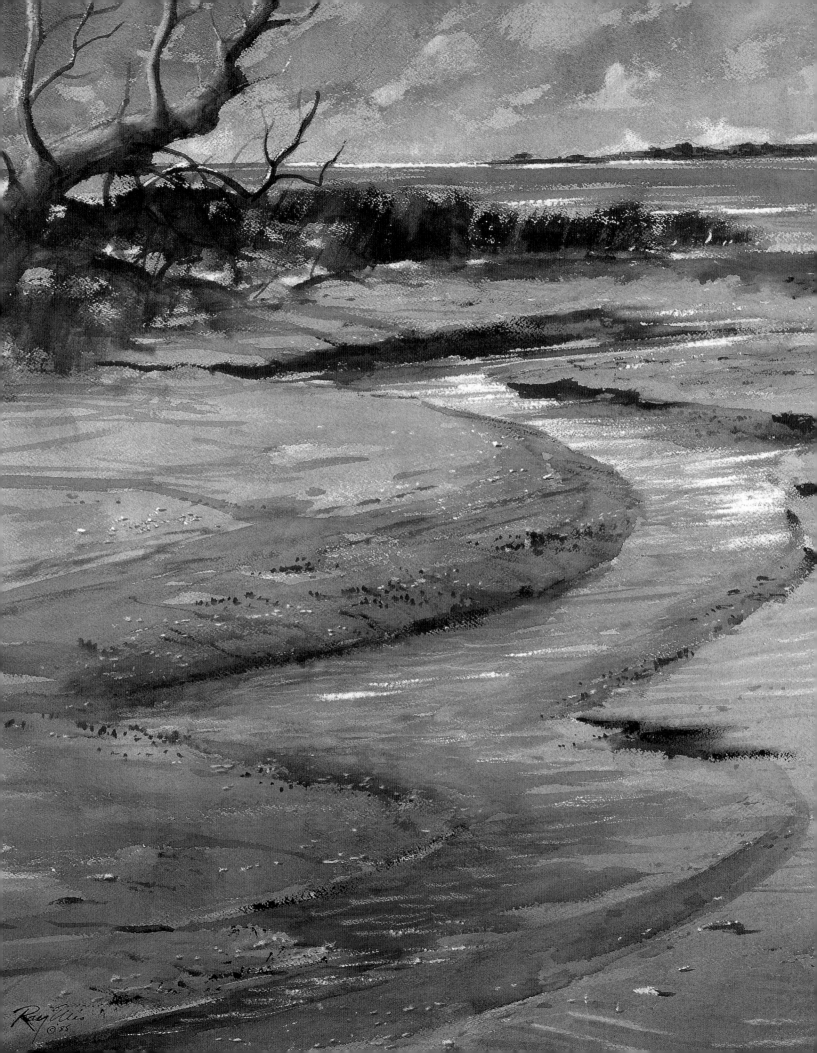

**99. BEACH GULLY**
*On Georgia's barrier islands rushing tides and currents often leave huge gullies and cuts in the sand. This one at St. Catherine's Island made a good subject with the drift-wood hanging over it.*

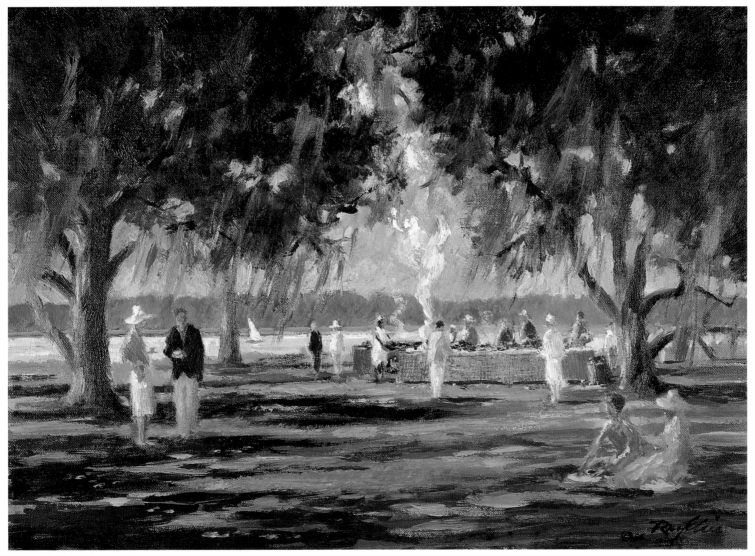

**100. OYSTER ROAST**
*One of the most popular forms of entertaining in Savannah and the Lowcountry is having the oyster roast. This ritual has been going on for centuries. The painting was inspired by one on the Wilmington River near Porpoise Point.*

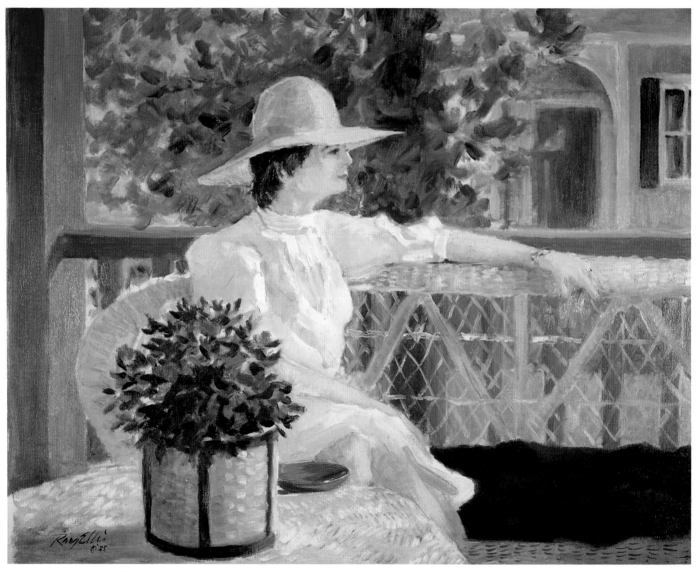

**101. AFTER CHURCH**

*On hot summer Sundays, we often had iced tea on the porch of our Savannah home after church. The sight of my wife sitting on the wicker settee inspired me to get out my paints and capture the moment. The painting now hangs in the living room of our Martha's Vineyard home where it brings daily reminders of our life in Savannah.*

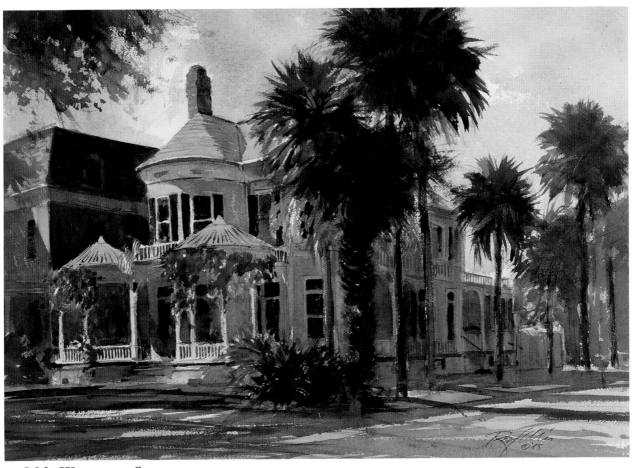

**102. WHITAKER STREET**
*Living across the street from this beautiful Victorian house gave me a chance to see it in every season. In the spring, wisteria covered nearly every inch of the unique, double gazebo porch.*

**103. THE GAZEBO**

## 104. BACK CREEK

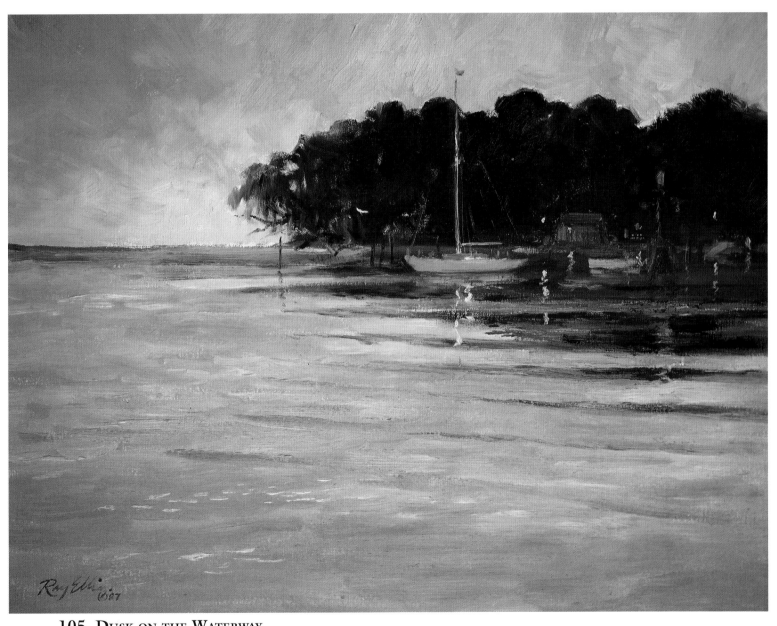

**105. Dusk on the Waterway**
*A simple bend in the Wilmington River with a sloop at the dock typified the tranquility of much of the Waterway.*

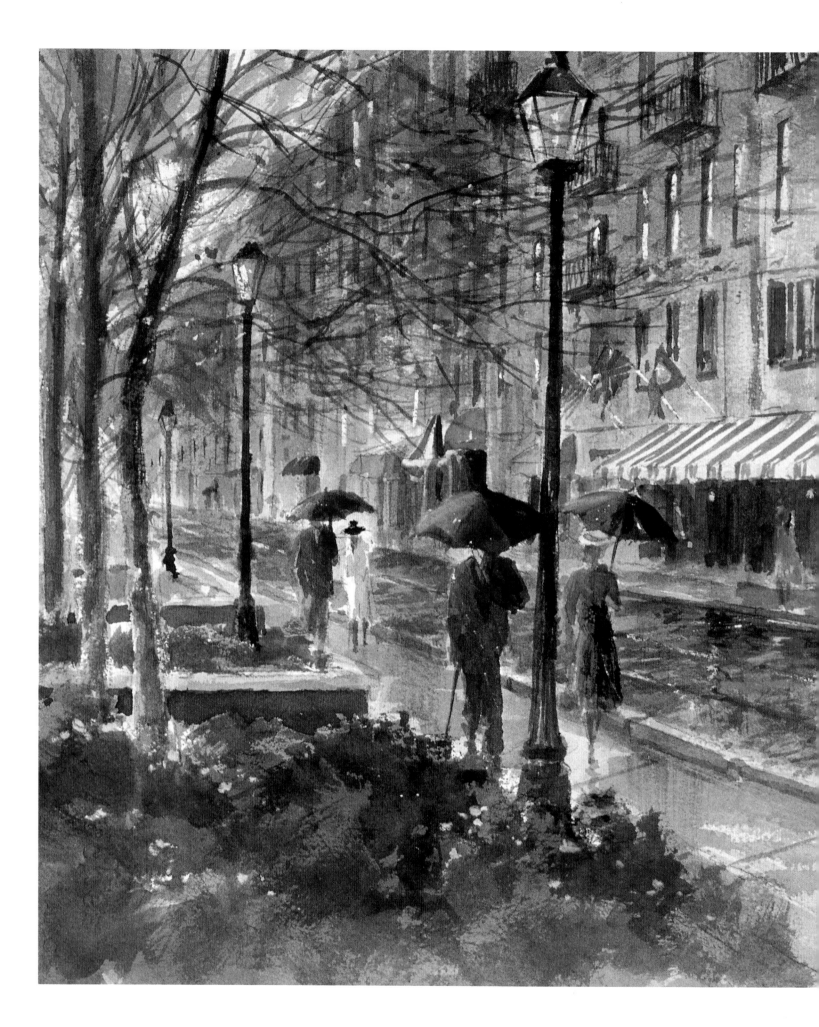

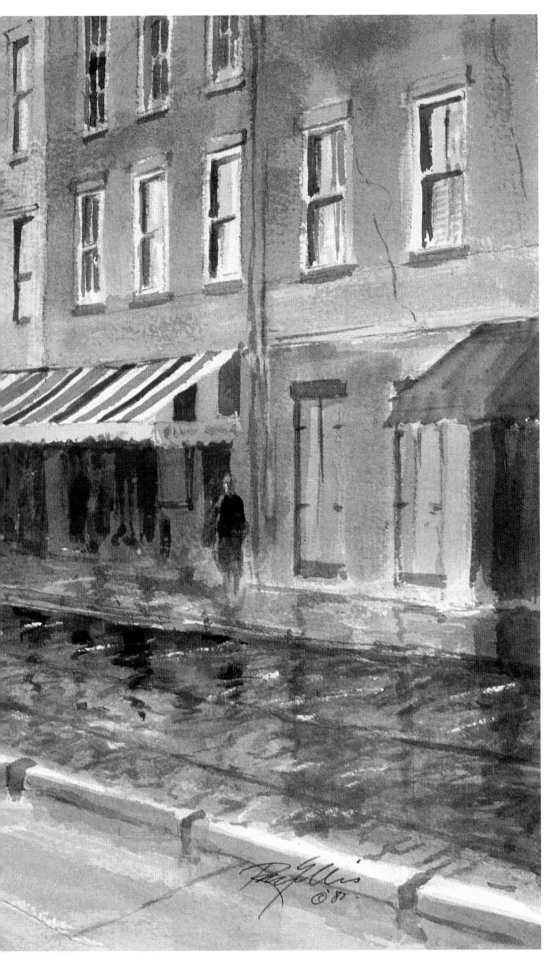

**106. RIVER STREET**
*River Street in Savannah is probably the best known street and the one most visited by tourists. Here an afternoon shower cast reflections on the cobblestones.*

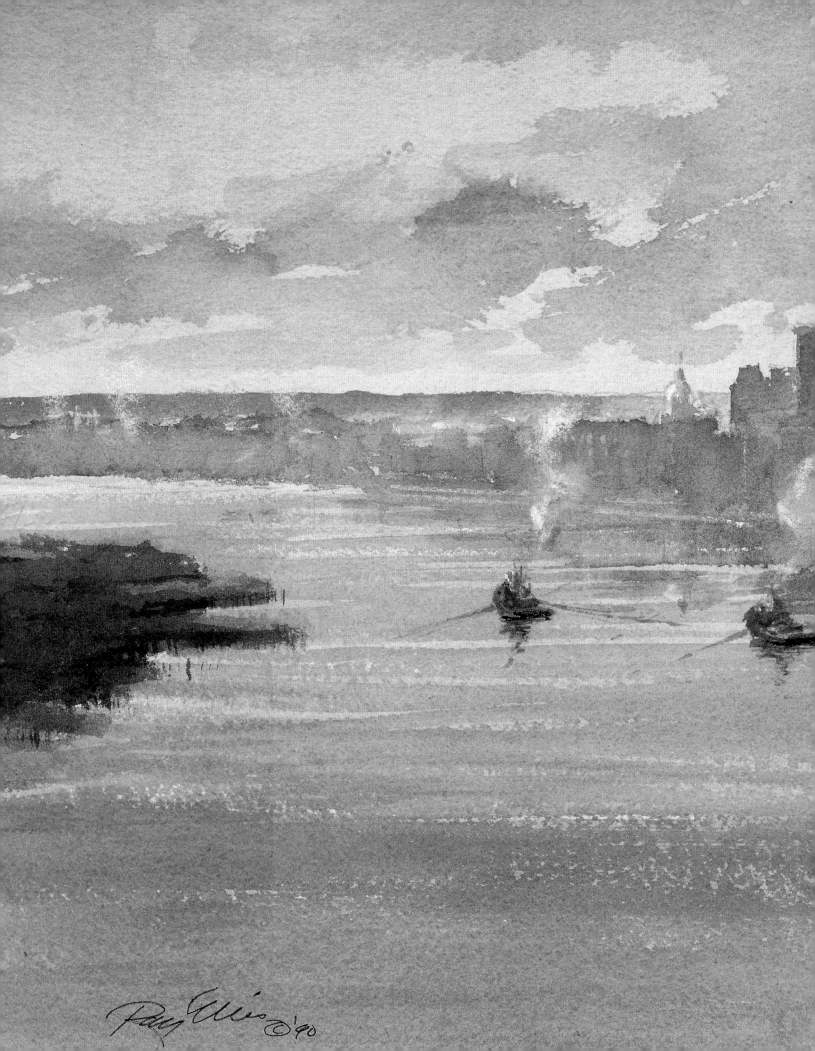

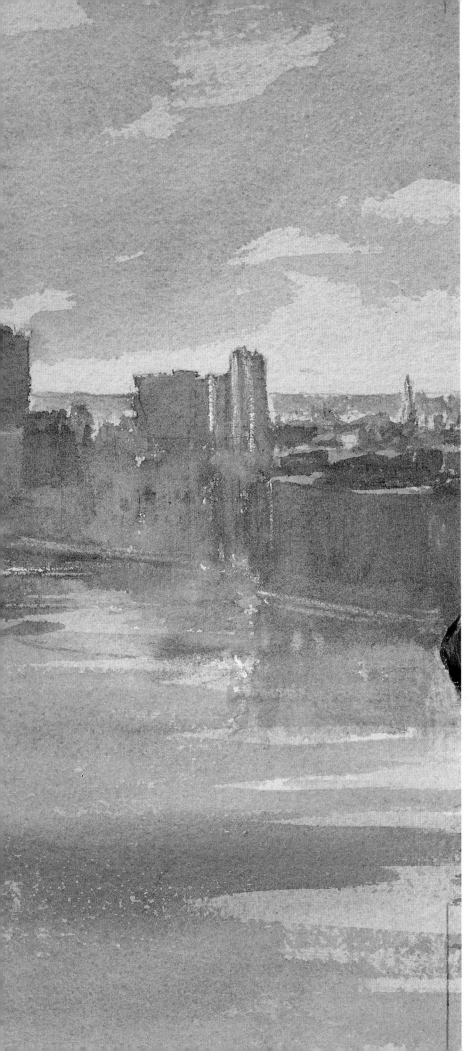

**107. MORNING—SAVANNAH HARBOR**
*In this painting, two tugs can be seen returning to their moorings after escorting a freighter to its berth early in the morning. My vantage point was from the old Talmadge Bridge. The city is veiled in shades of lavender and blue.*

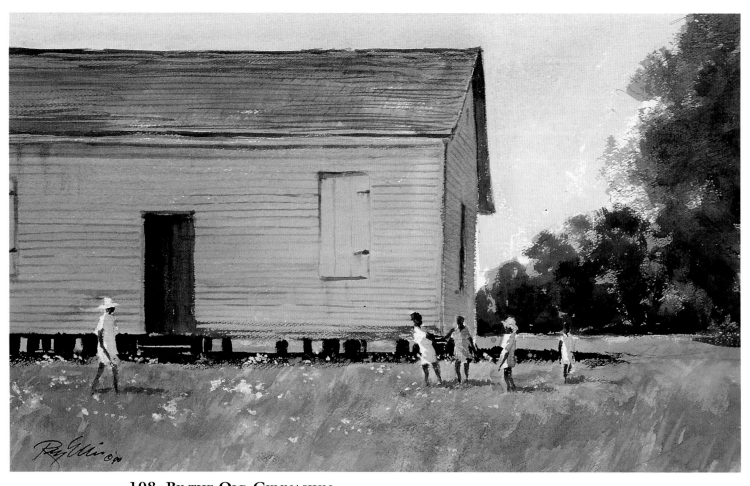

**108. By the Old Gymnasium**
*Many of the old buildings still stand at the Penn School on St. Helena's Island. Here I wanted to capture the joy of children playing next to the old gymnasium.*

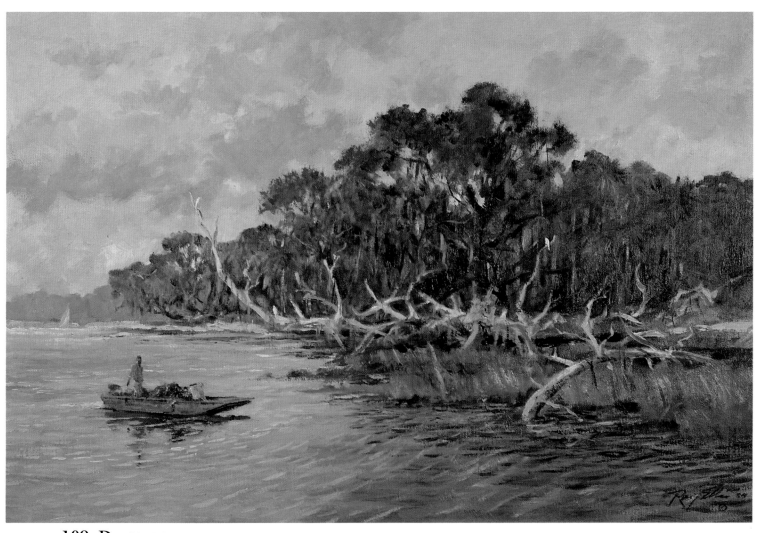

**109. DRIFTWOOD**

*On the Waterway going by Daufuskie Island, there are huge pieces of bleached drift-wood. They form many patterns along the shore of the Cooper River, like giant dinosaur skeletons.*

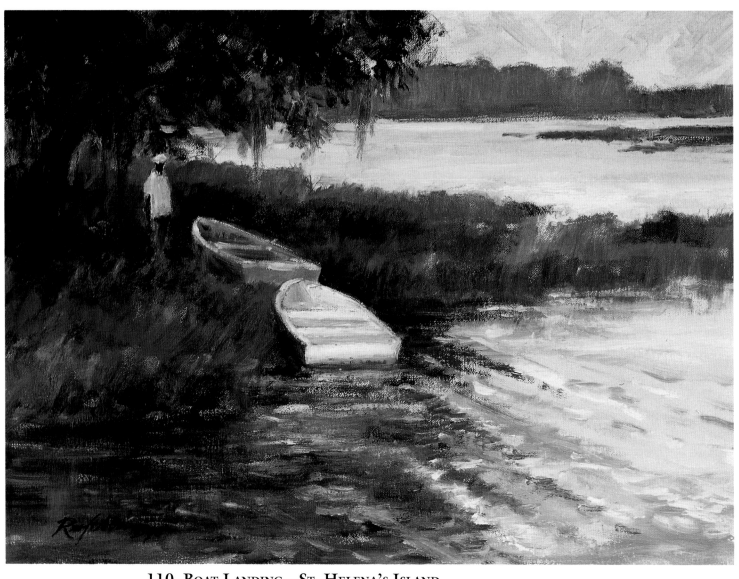

**110. BOAT LANDING—ST. HELENA'S ISLAND**

*Two white boats at low tide made a wonderful contrast, but the addition of the figure in red pants added the touch of color the painting needed. My days at St. Helena's were always fruitful, and I felt that I had stepped back in time.*

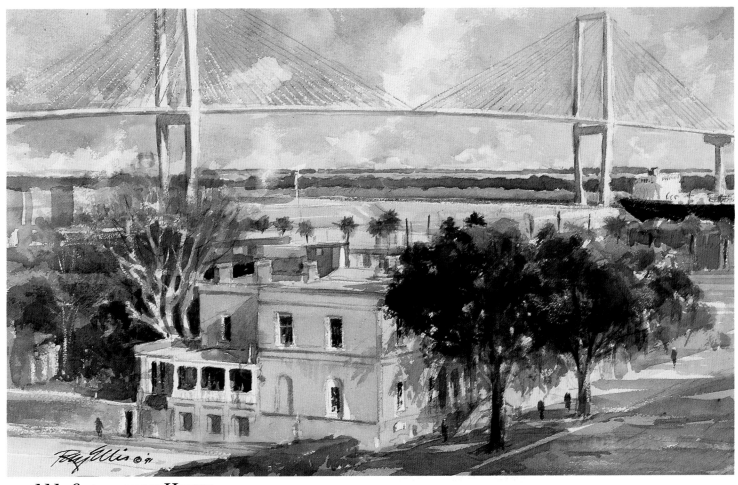

## 111. SCARBROUGH HOUSE

*This view of Scarbrough House from the top of one of the buildings on West Broad Street also shows the recently-opened bridge over the Savannah River. Scarbrough House was built in 1819. I was fortunate to have two shows in this fine old mansion. William Jay of Bath, England, was the architect.*

133

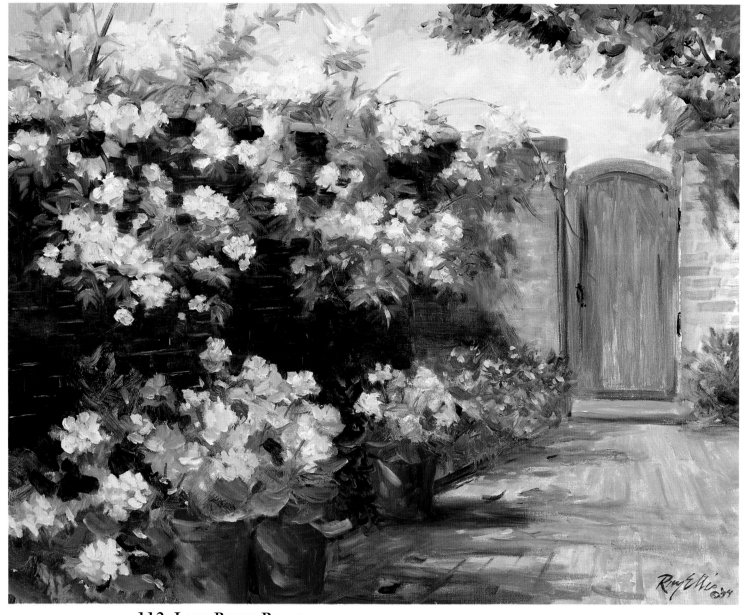

**112. Lady Banks Roses**

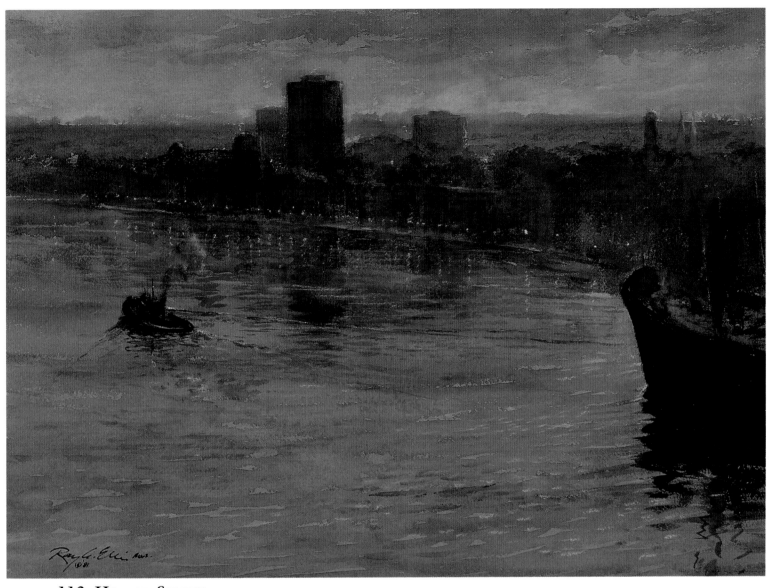

**113. Harbor Sunset**

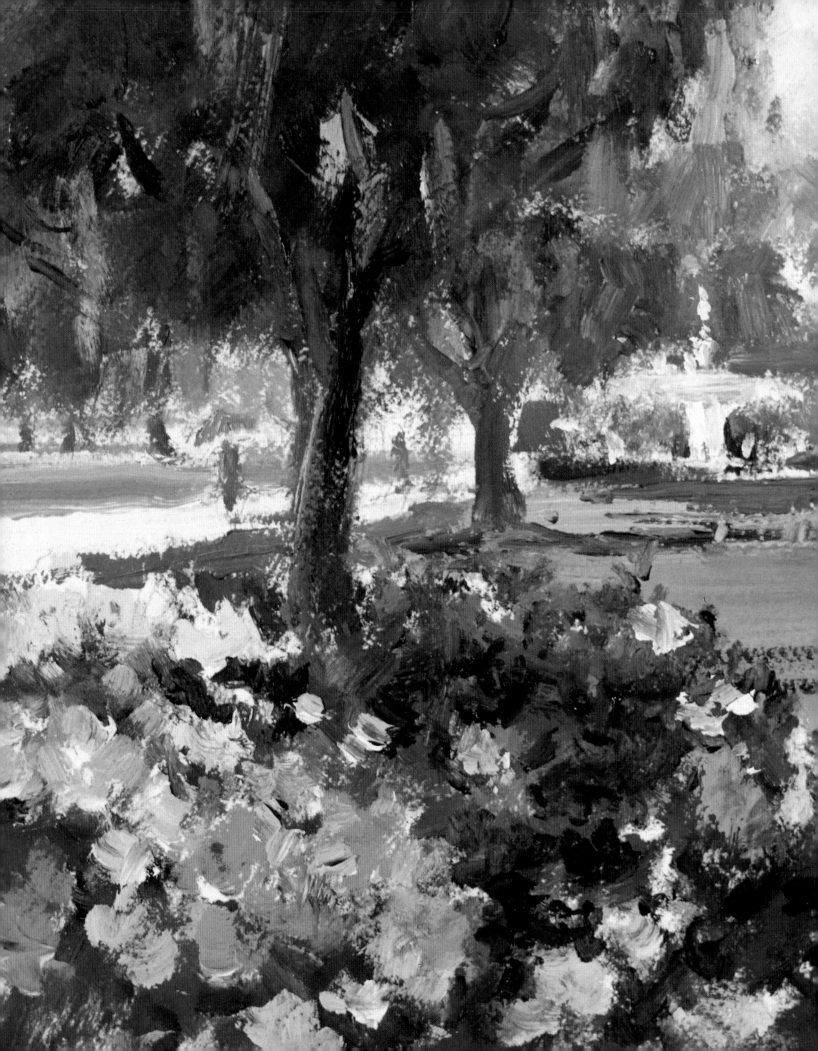

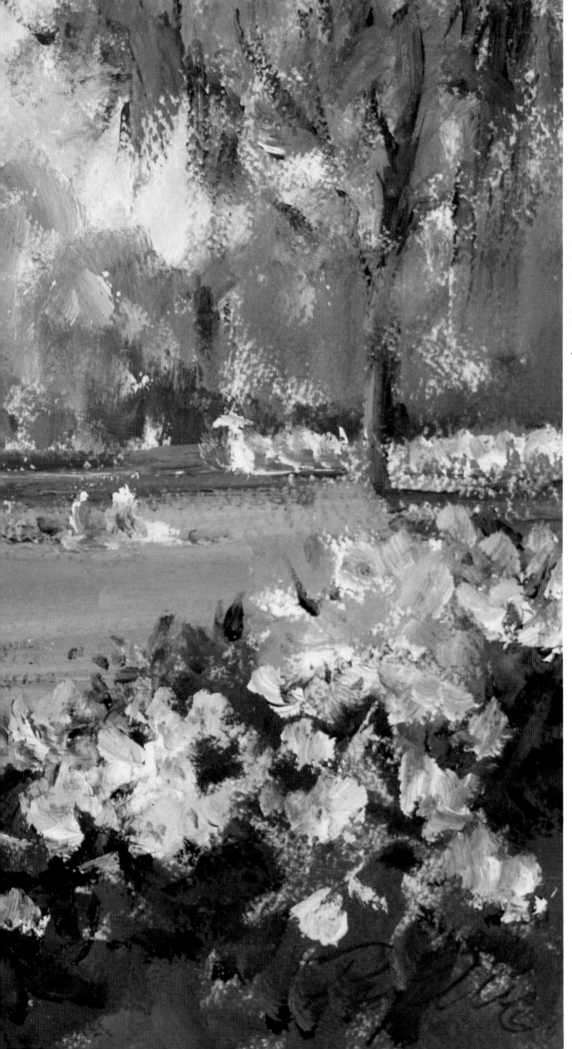

**114. Spring at Forsyth Park**
*This park is never as beautiful as it is in the spring when the azaleas are in full bloom. Picnickers choose their favorite spots, and people promenade around the paths.*

137

**115. Trumpet Vine**

*I came to know this vine because it grew all over my studio and back part of my house in Savannah. It is insidious and very strong. Once I found it growing through a crack in the foundation into a room! In spite of its destructive nature, I continue to love this vine with its brilliant red trumpet-like flowers.*

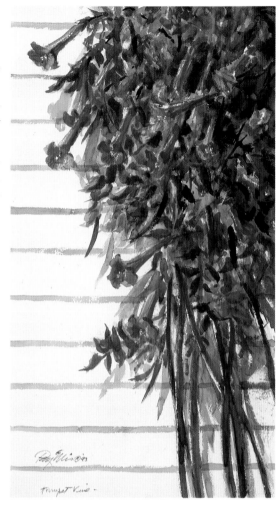

**116. Surveying the Field**

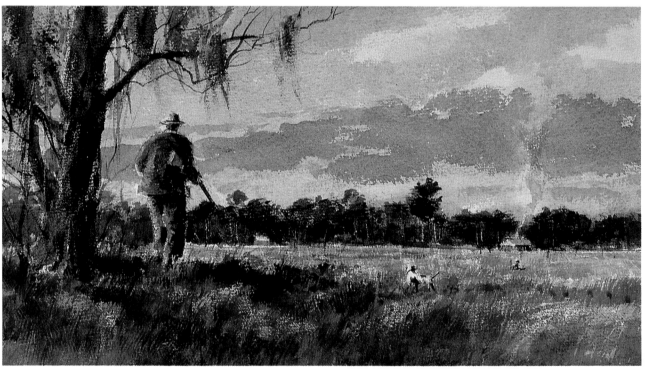

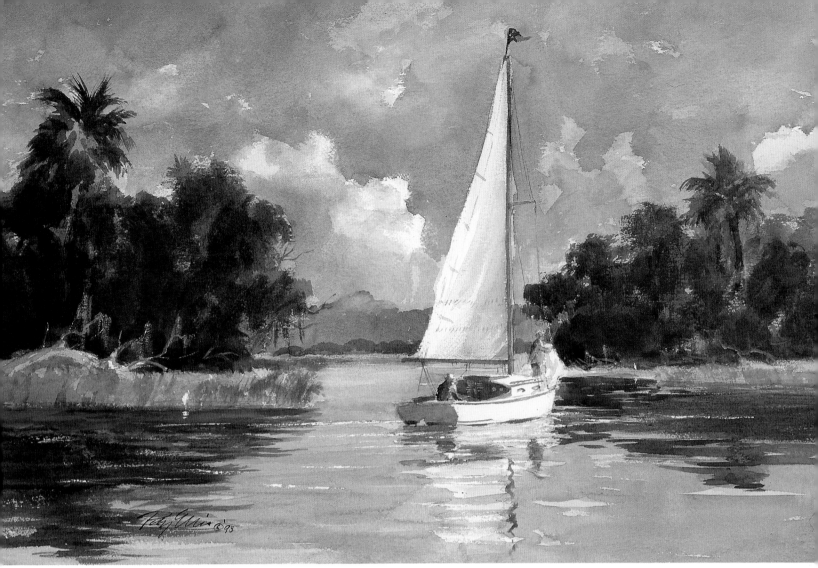

## 117. QUIET LAGOON

*Dropping sail in a quiet lagoon at the end of the day is one of the great pleasures of my sailing experiences and has inspired many a painting. Finding such a place is easy in this part of the country.*

NEXT SPREAD:

## 118. CASTING FOR SHRIMP

*This setting captured the rich, dark colors of a back-creek cove contrasting with the brightness of the water. The sun picked out the white clad figures and highlighted the smoke from the beach fire.*

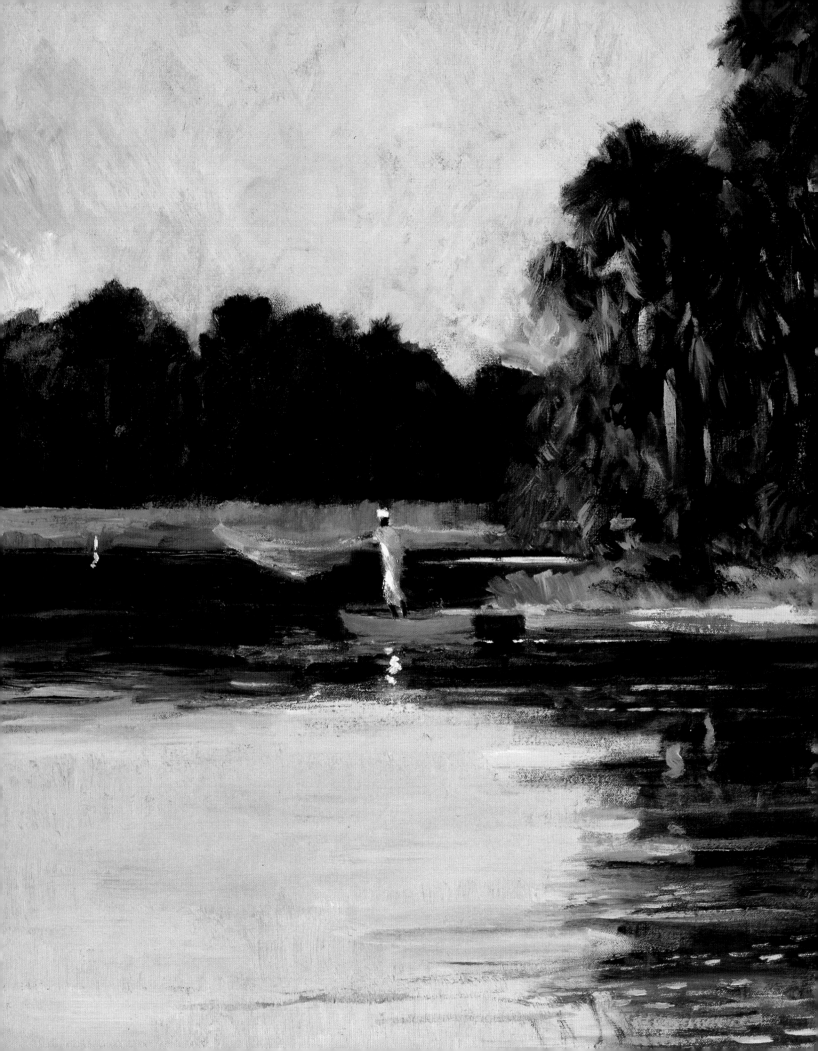

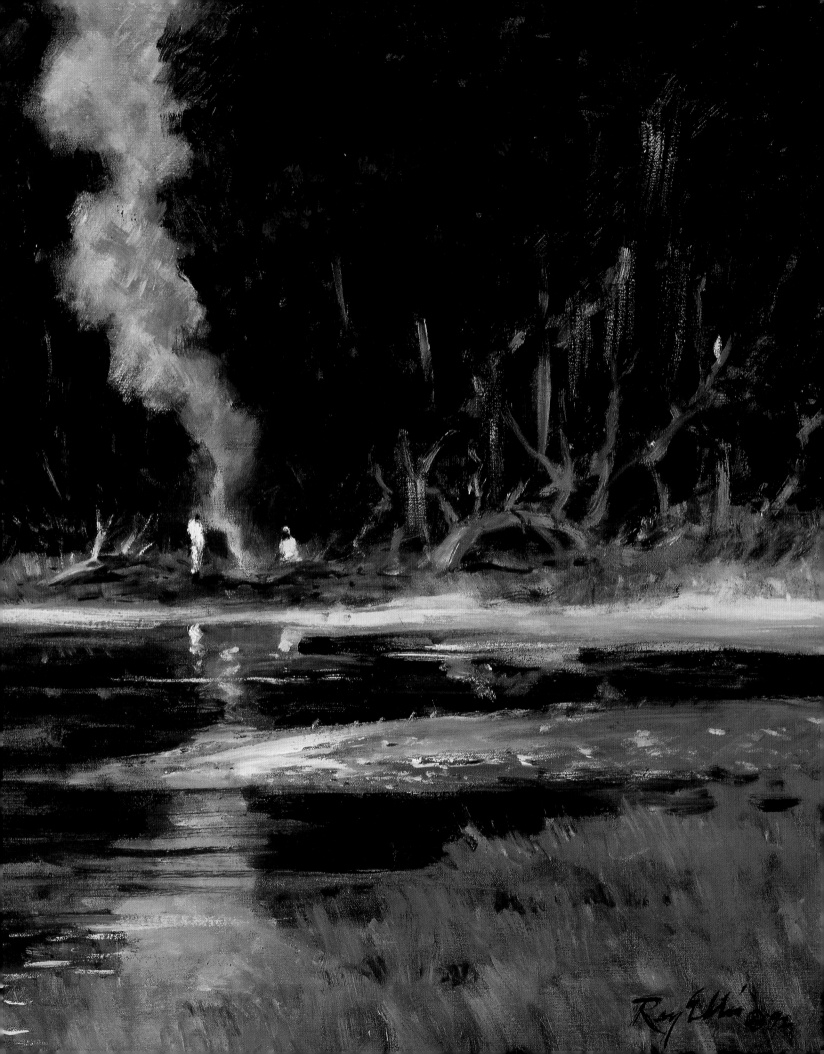

# Catalog of Paintings

1. Bluffton Oystermen
*8 ¼" x 11", Watercolor*
2. Harbour Town in Fog*
*17" x 23", Oil*
3. Daffodil Farm
*22" x 35 ½", Watercolor*
4. The Endless Marsh*
*24" x 30", Oil*
5. Blue Heron
*13" x 8 ¾", Watercolor*
6. Wisteria
*7 ½" x 10", Watercolor*
7. Tugs at Savannah Harbor
*17" x 28", Watercolor*
8. Station Creek
*24" x 40", Oil*
9. Wildflower Field
*20" x 24", Oil*
10. Down River
*5 ½" x 11", Oil*
11. Winter Morning
*16" x 22", Watercolor*
12. Through The Marsh
*17" x 29", Watercolor*
13. St. Helena Marsh
*18 ¼" x 24", Watercolor*
14. Beach Party
*10" x 12", Watercolor*
15. Oyster Season
*24" x 28", Watercolor*
16. Bass Fisherman*
*5 ½" x 6 ½", Watercolor*
17. Shrimp Fleet at St. Helena
*16" x 20", Oil*
18. Fishing the Prince River
*8" x 12", Oil*
19. Summer Crops
*11" x 18", Oil*

20. Frogtown Church*
*5" x 7 ¾", Pencil*
21. Savannah Marsh
*15" x 20", Watercolor*
22. Savannah Rooftops
*30" x 40", Oil*
23. The Checker Game
*11" x 14", Oil on Paper*
24. The Checker Game II
*11 ½" x 14", Oil on Paper*
25. On The Point
*15 ½" x 25", Watercolor*
26. Tybee Light
*14 ½" x 21 ½", Watercolor*
27. St. Helena Lane
*10 ½" x 15", Oil on Paper*
28. Dusk at Harbour Town
*30" x 48", Oil*
29. Regatta
*40" x 50", Oil*
30. Duck Hunter at Dawn
*11" x 14", Oil on Panel*
31. Bass Strike
*20" x 34", Oil*
32. Shad Fishing
*10 ½" x 24 ½", Watercolor*
33. Predator*
*5 ¾" x 8", Watercolor*
34. Cat on the Marsh
*13 ¾" x 10 ¾", Watercolor*
35. Start of the Day
*40" x 48", Oil*
36. Granny Smiths
*7 ½" x 11", Oil*
37. A Special Place
*12 ½" x 24 ½", Watercolor*
38. The Midwife*

*15 ¾" x 21 ⅜", Watercolor*
39. Chicken Yard
*7 ¾" x 10", Oil on Paper*
40. Ferrying Marsh Grass
*11" x 14", Oil on Panel*
41. Trolling*
*16" x 21", Watercolor*
42. Looking for a Point
*13" x 24", Watercolor*
43. Owens-Thomas House, Savannah
*13 ½" x 19 ½", Watercolor*
44. West Forsyth Park, Savannah*
*16" x 20", Oil*
45. The Live Oak
*24" x 36", Oil*
46. Off The Point At Dusk*
*9" x 12", Oil*
47. On The Oyster Flats
*24" x 36", Oil*
48. Beach Reflections
*23" x 31", Watercolor*
49. Daufuskie Oystermen
*24" x 36", Oil*
50. On The Tidal Creek*
*9" x 12", Oil on Panel*
51. Rama's Porch
*18" x 24", Oil*
52. Near The Cathedral, Savannah*
*6 ¾" x 10", pencil*
53. River Street Sketch*
*7 ½" x 11 ½", Watercolor*
54. Owens-Thomas Garden
*15" x 20", Watercolor*
55. Anticipation*
*12" x 24", Watercolor*

56. **Start of the Day**
*13 ¾" x 17", Watercolor*
57. **Daufuskie Porch**
*15" x 24", Watercolor*
58. **Waiting**
*18 ⅛" x 22 ⅞", Watercolor*
59. **Old River Street, Savannah**
*11" x 18", Watercolor*
60. **Oysters On The Half Shell**
*11" x 14", Oil*
61. **Cathedral Spires, Savannah**
*14" x 20", Watercolor*
62. **Winter Marsh***
*5" x 7", Watercolor*
63. **City Market Area,
    Savannah***
*8 ¾ x 12 ½, Watercolor*
64. **Hunter's Shack**
*11" x 14", Oil*
65. **Moon River IV**
*11" x 14", Oil*
66. **Lowcountry Dock**
*24" x 36", Oil*
67. **On The Shallows**
*8" x 14", Watercolor*
68. **Monday Morning—River
    Street***
*21" x 28", Watercolor*
69. **Back From The Hack***
*11" x 9", Watercolor*
70. **Old Talmadge Bridge**
*15" x 21", Watercolor*
71. **Tidal Creek**
*16" x 25", Watercolor*
72. **Ossabaw***
*16" x 20", Oil*
73. **Old City Market**
*14" x 20", Watercolor*
74. **Water Lilies**
*9"x 12", Oil*
75. **Marsh Dweller**
*17" x 29", Watercolor*
76. **Oak Tree Swing**

*14" x 20", Watercolor*
77. **Fall Marsh***
*5 ¼" x 7", Watercolor*
78. **Marsh Clouds**
*9" x 12", Oil*
79. **Roasting Oysters**
*8" x 10", Oil*
80. **Morning on the Ogeechee**
*20" x 30", Oil*
81. **Summer Garden**
*22" x 28", Oil*
82. **Southern Garden**
*18" x 24", Oil*
83. **The Viewers**
*18" x 20", Watercolor*
84. **Morning Off Tybee**
*20" x 30", Oil*
85. **Savannah River**
*9" x 12", Oil*
86. **Garden Corner**
*20" x 30", Oil*
87. **Dusk on the Sound**
*24" x 40", Oil*
88. **Oscar's Place**
*22" x 29", Watercolor*
89. **Sky Line From Savannah
    Golf Club**
*24" x 36", Oil*
90. **Lowcountry Farm**
*12" x 18", Oil*
91. **Southern Cat**
*8 ¼" x 13 ¼", Watercolor*
92. **Daufuskie Road**
*7 ½" x 11", Watercolor*
93. **On the Waterway**
*30" x 36", Oil*
94. **Bay Street, Savannah**
*14" x 25", Watercolor*
95. **Drifting Along the Marsh***
*18" x 26", Watercolor*
96. **Bowl of Daffodils**
*3 ½" x 5", Watercolor*

97. **Oysterman**
*19" x 30", Watercolor*
98. **Morning For Ducks**
*9" x 12", Oil on Panel*
99. **Beach Gully**
*25" x 18", Watercolor*
100. **Oyster Roast**
*12" x 16", Oil*
101. **After Church**
*20" x 24", Oil*
102. **Whitaker Street, Savannah**
*14' X 20", Watercolor*
103. **The Gazebo**
*13 ½" x 18 ½", Watercolor*
104. **Back Creek**
*24" x 36", Oil*
105. **Dusk on the Waterway**
*18" x 26", Oil*
106. **River Street, Savannah**
*14" x 21", Watercolor*
107. **Morning—Savannah
     Harbor***
*13" x 15 ½", Watercolor*
108. **By The Old Gymnasium**
*13" x 24 ½", Watercolor*
109. **Driftwood**
*24" x 36", Oil*
110. **Boat Landing, St. Helena**
*12" x 18", Oil*
111. **Scarbrough House,
     Savannah**
*12 ½" x 20", Watercolor*
112. **Lady Banks Roses***
*20" x 24", Oil*
113. **Harbor Sunset**
*21" x 28", Watercolor*
114. **Spring at Forsyth Park**
*8" x 10 ½", Oil on Paper*
115. **Trumpet Vine***
*24 ½" x 13", Watercolor*
116. **Surveying The Field***
*14" x 21 ½", Watercolor*
117. **Quiet Lagoon**
*16 ½" x 24 ½", Watercolor*
118. **Casting For Shrimp**
*24" x 36", Oil*
119. **Setting Out**
*9" x 12", Watercolor*

*Property of *Compass Prints, Inc.*
  205 West Congress Street • Savannah, Georgia
31401 • 1-800-752-4865
  All other paintings are in private collections.

# Savannah and the Lowcountry

Design by
*Bob Nance*
Auburn, Alabama

Manufacturing by
*Friesen Printers*
Manitoba, Canada

Photography of art by
*Ross Meurer*
*Joseph Byrd & Associates*
*Hansell Ramsey*

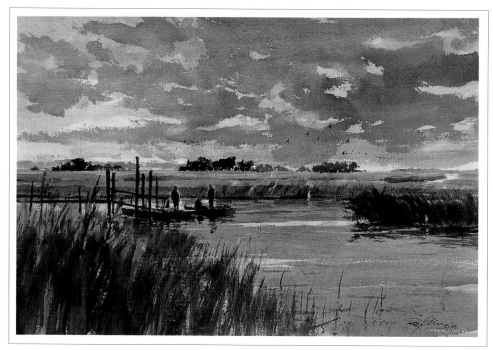

**119. SETTING OUT**
*The dogs' excitement matches that of the
hunters as they all gather at the
dock for a morning of
duck hunting.*

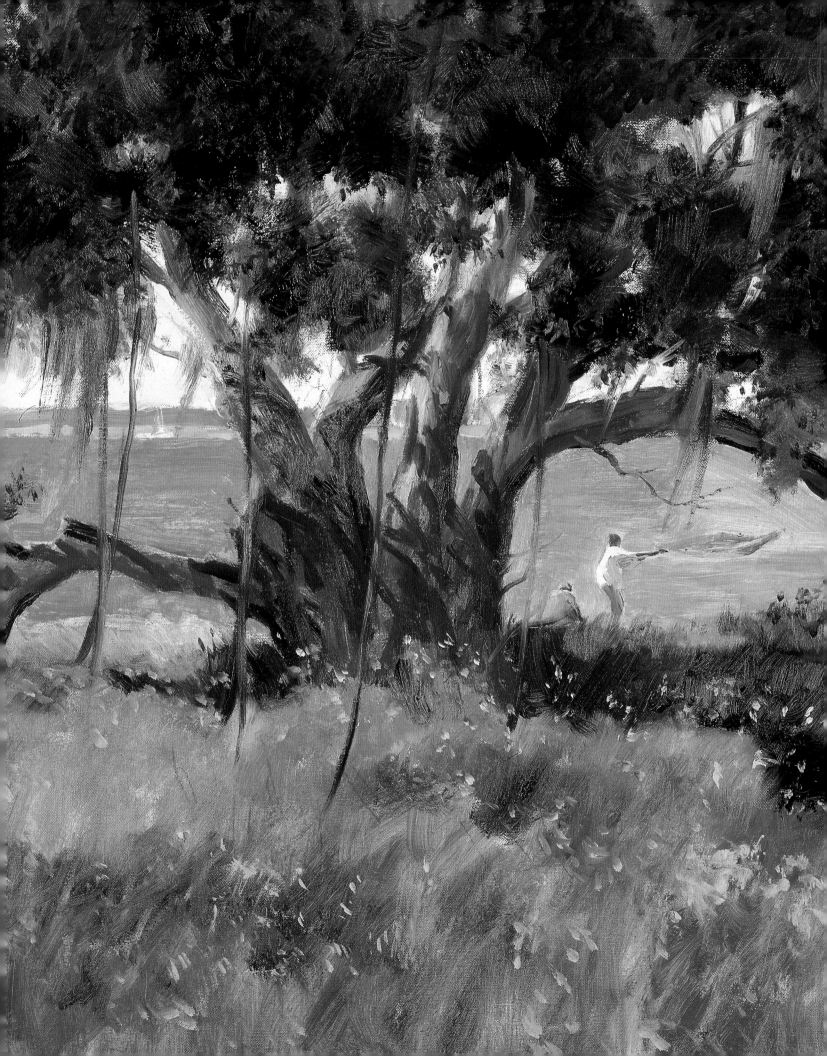